Different strokes:
pencil drawing

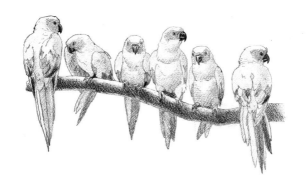

Different strokes:
pencil drawing

David Poxon

A QUARTO BOOK

Copyright © 2008 Quarto Inc.

First edition for North America
published in 2008 by

Walter Foster Publishing, Inc.
23062 La Cadena Drive,
Laguna Hills, CA 92653
www.walterfoster.com

Walter Foster is a registered trademark.

ISBN-13: 978-1-60058-054-3
ISBN-10: 1-60058-054-8
UPC: 0-50283-43203-6

Conceived, designed, and produced by
Quarto Publishing plc
The Old Brewery
6 Blundell Street
London
N7 9BH

QUAR.DSD

Project Editor **Anna Amari-Parker**
Editorial Assistant **Robert Davies**
Managing Art Editor **Anna Plucinska**
Designer **Michelle Cannatella**
Photographer **Martin Norris**
Proofreaders **Susannah Wight and Tracie Davis**
Indexer **Diana Le Core**
Picture Researcher **Claudia Tate**
Art Director **Caroline Guest**
Creative Director **Moira Clinch**
Publisher **Paul Carslake**

Manufactured by PICA Digital, Singapore

Printed in China by 1010 Printing International Limited

9 8 7 6 5 4 3 2 1

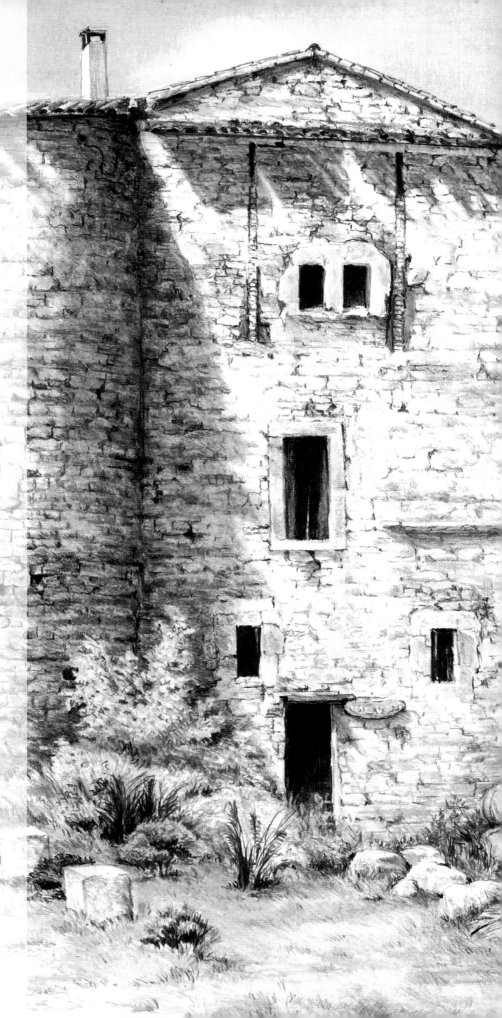

Contents

Introduction

This truly inspirational book provides a unique chance to look over the shoulder of 15 practicing artists. The upfront Getting Started section offers advice and tips and identifies the skills and equipment needed to work alongside these professionals. Follow every move and considered mark through the varied projects in the Comparing Techniques section. Each artist has been randomly teamed up with another, and each pair has been given an identical reference image. As the artists work separately and alone, see how they tackle proportion, perspective, tonal range, and composition, all the while using their skills and experience of sketching and

About this book

Being faced with a blank sheet of paper can induce both excitement and fear in beginning and experienced artists alike. In this book, different subjects are tackled by two artists simultaneously. A series of step-by-step sequences show how the initial decisions and subsequent choices radically affect the final outcome.

The core of the book is made up of 15 projects. In each demonstration, the sequence of steps followed by each artist is laid out clearly, so you can easily compare, contrast, and understand the different methodologies and approaches that are involved. Although both artists share the same starting point, the outcomes often are vastly different. Sometimes artists might work in very different ways but then use a similar technique to describe, for example, the shape or depth of a shadow. Refer to the "mirrored" stage sequences to understand the working methods of each artist.

The various drawing techniques and pencil marks are shown and explained in detail.

GETTING STARTED

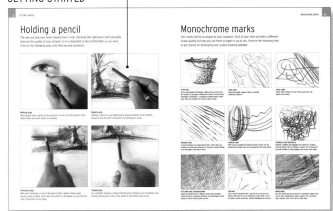

COMPARING TECHNIQUES

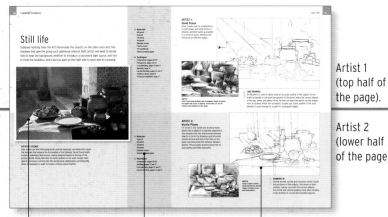

Artist 1 (top half of the page).

Artist 2 (lower half of the page).

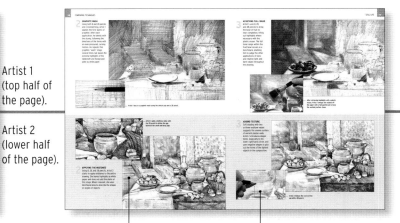

The photograph shows you the common starting point for both artists.

The materials and techniques used by each artist are listed in order.

Any sketches or preparatory studies by the artist are shown.

Large, clear photographs show each artist's unique methodology. All stages appear at the same scale for easy comparison.

Detailed, close-up views of the individual steps allow you to see all the equipment, marks, and techniques used.

drawing to best fulfill their objective. The styles and approaches are analyzed and compared. Each project features a list of required drawing materials, and the instructions explain where and how the artists use them. Every step of your artistic journey is punctuated with sound advice and hands-on tips. Make time to begin and take your time to enjoy!

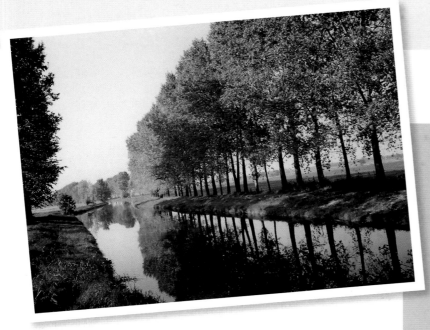

A series of photographs was specially selected to show a broad range of subjects. These images represent a common point of reference for both artists, and you can see how each individual interprets the subject in his or her own way.

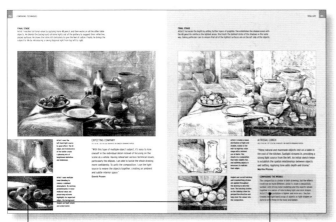

Detailed insets highlight the same sections from both works for comparing.

A box feature summarizes both approaches to the same subject.

Working from the photographs in this book

Photographs make great resource material, and artists use them in different ways: from a simple, initial impulse for remembering the effect of light on a landscape or some technical detail to freezing movement and creating a photorealistic representation. Use the photographs in this book as a springboard for your own interpretation after comparing the methods of the featured artists. You'll find that you can mix techniques from different demonstrations to produce your own unique drawings.

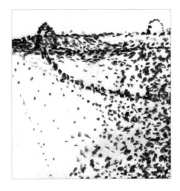
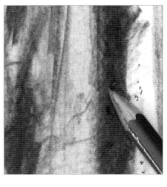
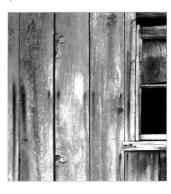

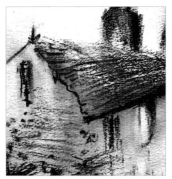

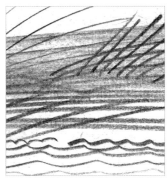

Getting

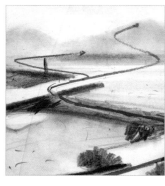
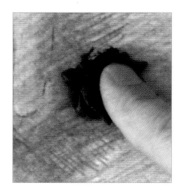

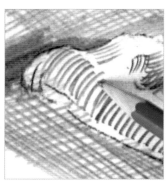

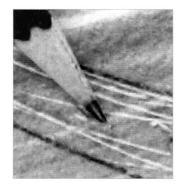

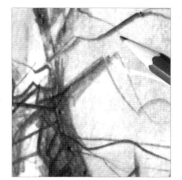

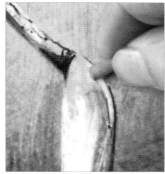
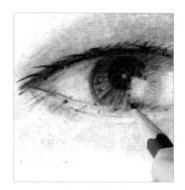

started

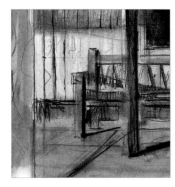

Pencil drawing immediately conjures up an image of graphite pencils, but there are a great many other interesting media you can explore, such as colored and watercolor pencils. This section explains the properties of different drawing and sketching tools and describes the methodology and applicability behind specific techniques in detail. Let's get started!

Tools and materials

Your equipment contributes to the quality of art you produce, so purchase the best you can afford. In many ways, it will shape your enjoyment of your artistic journey. Meet the real workhorses in any artist's stable of tools and materials.

Graphite pencils

Every artist should have a small selection of pencils at hand. The wooden shaft contains a graphite and clay core. Manufacturers use letters and numbers to rate the hardness or softness of that core. The letter H stands for hardness and the letter B for blackness; the higher the accompanying number, the harder or blacker the graphite.

H: indicates the hardest range. Use H pencils for pale silver tones and lines.

B: an all-arounder must for any drawing kit. Use it for detail, linework, and blocking in initial tones.

2B: darker than a B pencil. After the first tones, it's generally a good idea to reinforce your drawing with a 2B.

4B: much softer and darker. Use only in dark areas.

6B: hard to keep a point. Some artists use it for bold sketching. Used sparingly, a 6B can be effective for extreme shading.

Charcoal pencils

Like their graphite cousins, charcoal pencils are encased in a wooden shaft. They are much cleaner to use than traditional willow charcoal and come in three grades (light, medium, and dark).

LIGHT: the lightest and hardest of the charcoal pencil range but still very dark!

MEDIUM: a little darker and softer. Use for basic linework and initial charcoal tones.

DARK: very dark and soft. Best for big, bold strokes where precision is not needed.

Clutch pencils

Clutch pencils are similar to mechanical pencils but hold thick leads (usually 2mm thick). They are more expensive than their wooden counterparts, but they have a few advantages. Not only is sharpening an unnecessary task, but the pencil weight is always consistent.

Graphite sticks

Useful for blocking in large areas of tone, a graphite stick is a solid piece of graphite without casing. It can produce a range of very dark marks.

Erasers

There are two main types of erasers: plastic and kneaded. An eraser is a vital piece of equipment. Use it to remove errors or as a drawing aid when you want to reclaim areas of a drawing that are too dark.

PLASTIC ERASER: harder than a kneaded eraser, a plastic eraser also does the job. When the eraser becomes dirty, simply clean it with an abrasive surface such as sandpaper.

KNEADED ERASER: made from a soft material that you can easily shape; dab rather than rub the area you wish to erase.

Drawing papers

Available in pads or as single sheets, there is an infinite variety of drawing papers available, from machine made to hand finished. Smooth, heavyweight drawing paper is suitable for most drawing work and works best for blending techniques. Rough paper is suited to heavy, textured effects and charcoal work.

Sharpeners

As pencils become blunt with continual use, a small sharpener will give you a consistent point. Sharpened pencils are needed for detailed work.

Blending stumps

Available in a range of sizes, these rolled-up cardboard stumps are great for blending applied graphite. Use them to soften hard edges and achieve smooth tones.

Fixative

Consider spraying the surface of your drawing in order to protect it: otherwise it may smudge and fade away. Follow the manufacturer's instructions.

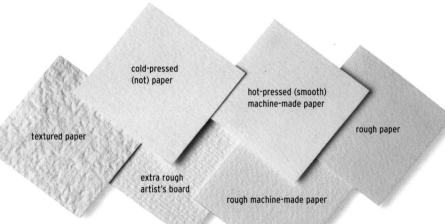

textured paper

cold-pressed (not) paper

hot-pressed (smooth) machine-made paper

rough paper

extra rough artist's board

rough machine-made paper

Canvas wrap

Keep all of your drawing essentials organized in a roll-up canvas wrap with holders for your incisor tool (see page 13), pencils, erasers, and blending stumps.

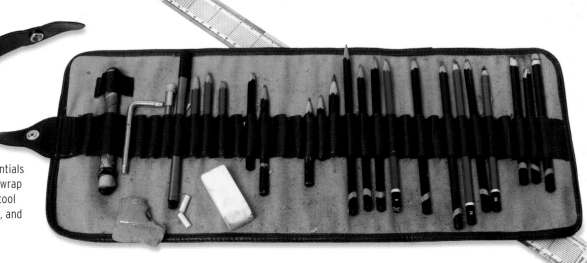

Holding a pencil

The way you grip your main drawing tool is vital. Choosing the correct hand position will noticeably improve the quality of your artwork, so it is important to feel comfortable as you work. Practice the following grips until they become automatic.

Writing grip
Holding the pencil in the same way that you write gives you a lot of control. You'll want to use this grip for fine detail work that requires precision.

Sketch grip
Gripping the pencil as you might hold a spoon promotes more rhythmic linework. You can use this hand position to quickly and loosely block in a subject.

Pressure grip
Holding the pencil at an angle with your forefinger on top of the shaft allows you to apply a lot of pressure. Use this grip for shading darkly or covering large areas quickly.

Thumb grip
Grasping the pencil between your forefinger and thumb, as shown, allows for loose yet confident linework. Try this position when you want to create free, uncontrolled marks.

Monochrome marks

Your marks will be as unique as your signature. Each of your tools provides a different stroke quality, but how you use them on paper is up to you. Practice drawing the following types of lines to start developing your unique drawing "alphabet."

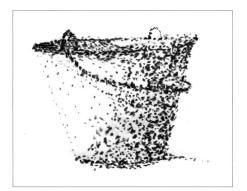

STIPPLE
Dot the paper with jabbing pencil marks—the denser the dots, the darker the value. This technique also is called "pointillism," which originally was a painting method developed by French artists in the nineteenth century.

THIN LINES
To create thin, wispy lines, use light pressure on a sharp point. Faint lines might suggest subtle or distant landscape features.

THICK LINES
For thick lines, use heavy pressure on a chisel point. Heavy, dark strokes will appear to be closer to the viewer than thin, light strokes.

BROKEN LINES
Create these irregular lines by varying the pressure on the pencil, almost lifting it off the paper occasionally. This is a good technique for suggesting texture.

CURVED LINES
Experiment with all four grips (see page 12) to draw circles and curves. Some lines will be precise, whereas others will be loose and sketchy.

SCRIBBLES AND SQUIGGLES
Make random scribbles and squiggles, varying your grip and the angle at which you hold the pencil. These marks are useful for creating textural effects such as foliage or fur.

HATCHING AND CROSSHATCHING
Drawing adjacent parallel lines is called "hatching." Add another layer at a different angle to "crosshatch." These techniques are used for building tone and describing form.

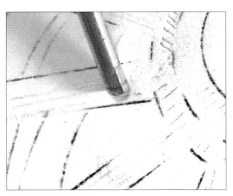

INCISING (IMPRESSING)
To retain the white of the paper in specific areas, use a hard, blunt incisor tool such as an Allen key, as shown, to make indentations in the paper.

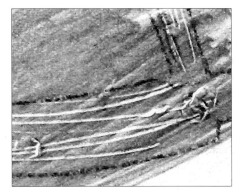

SHADING OVER IMPRESSED MARKS
Using the sketch grip, crosshatch rapidly from side to side with a pencil, skimming the indentations on the impressed surface which will now appear as white lines (page 33).

Colored pencils

There is a vast choice of colored pencils at your local art store. Begin with a small selection of colors, and choose pencils with a chalky consistency because this type is particularly suited to the techniques you will encounter in this book. Hundreds of colors are available, but start with the nine-color palette below and build from there.

Basic nine-color palette

The colors you choose will form your palette. Your basic palette should include one each of the three primary colors (red, blue, and yellow) and a limited range of complementary colors (see caption to color wheel below). Choose one very dark color and white to complete your spectrum.

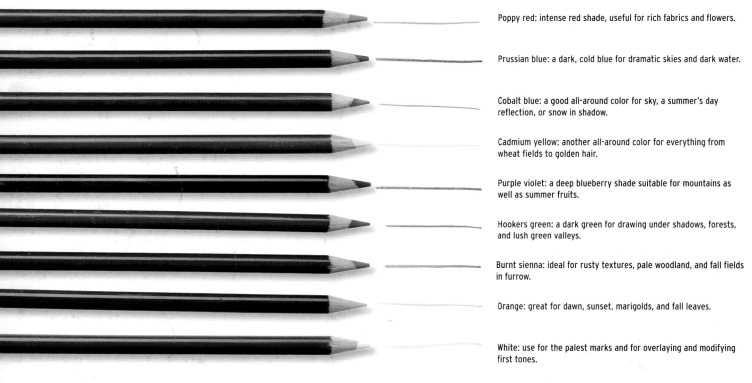

Poppy red: intense red shade, useful for rich fabrics and flowers.

Prussian blue: a dark, cold blue for dramatic skies and dark water.

Cobalt blue: a good all-around color for sky, a summer's day reflection, or snow in shadow.

Cadmium yellow: another all-around color for everything from wheat fields to golden hair.

Purple violet: a deep blueberry shade suitable for mountains as well as summer fruits.

Hookers green: a dark green for drawing under shadows, forests, and lush green valleys.

Burnt sienna: ideal for rusty textures, pale woodland, and fall fields in furrow.

Orange: great for dawn, sunset, marigolds, and fall leaves.

White: use for the palest marks and for overlaying and modifying first tones.

Color wheel

This color wheel shows how any two of the three primary colors (red, yellow, and blue) mix to make "secondary" colors. Purple is produced by mixing blue and red, green by mixing yellow and blue, and orange by mixing red and yellow. "Tertiary" colors are combinations of any primary color with the secondary color adjacent to it (for example, blue mixed with violet produces blue-violet). Any two colors opposite each other (green and red, blue and orange, and yellow and violet) are known as "complementary" colors and play a key role in color drawing. Set side by side, they create vibrant contrasts but they also can be mixed to produce neutral colors. If you have only a small set of colored pencils, try laying one complementary over another in different proportions. You will be surprised by how many hues you can achieve.

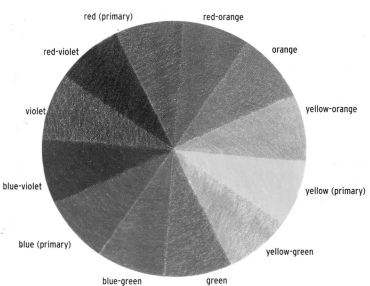

red (primary)
red-orange
red-violet
orange
violet
yellow-orange
blue-violet
yellow (primary)
blue (primary)
yellow-green
blue-green
green

Mark making in color

All the techniques and methods in this book are equally applicable to both colored and graphite pencils. When using colored pencils, however, you will notice that the marks might be slightly transparent. Overlay other colors to experiment with modifying initial tones. Be aware that it is difficult to erase marks in this medium, so start off lightly until you are confident about your drawing.

STIPPLE
When stippling (also see page 13) with colored pencils, you can use two colors to create the illusion of a third color. For example, stipple blue and yellow dots close together to create the illusion of green. This is called a "visual blend."

THIN LINES
Some types of colored pencils crumble easily so, when drawing thin lines, apply light pressure and sharpen your pencil as often as needed.

THICK LINES
The soft consistency of colored pencils allows for rich, expressive marks. Use a blunt tip or the side of the point to draw thick, bold lines.

BROKEN LINES
Using color when drawing broken lines adds to the textural quality of this technique as color helps emphasize the effect. For example, broken blue lines suggest rippled water, whereas broken brown lines resemble tree bark.

SCRIBBLES AND SQUIGGLES
As with broken lines, color enhances the textures created by scribbling and squiggling—for instance, green squiggles enhance the illusion of foliage.

HATCHING AND CROSSHATCHING
Overlaying two or more colors by hatching and crosshatching creates the illusion of a new color. This also helps suggest depth, as dark colors recede and light colors advance.

Choosing paper

The kind of paper you choose affects the appearance of your work. Smooth paper is best for general pencil work, including colored pencils, whereas a coarser grain is better for charcoals because the pigment locks into the surface of the paper.

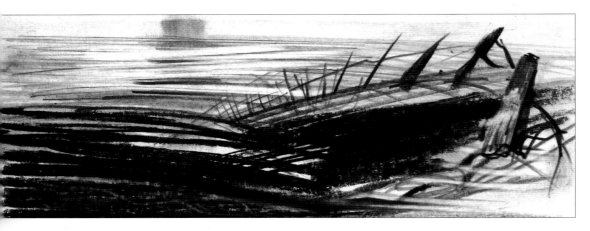

Smooth paper
In general, the heavier the weight, the better the quality. Use smooth paper for most drawing work, particularly if you want to blend areas together.

A mix of pencil and charcoal marks on smooth drawing paper.

Try making sweeping diagonal marks using the sketch grip on rough paper. This might suggest long, windswept grasses.

Heavy vertical lines are reserved for the darkest part of the window recess. The crumbling charcoal adds character to this old cottage.

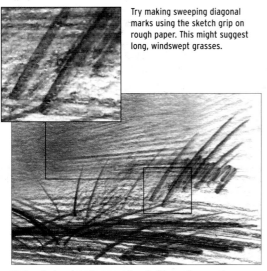

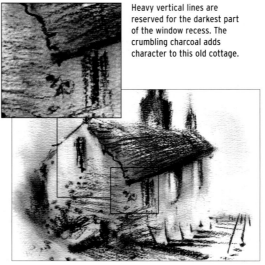

Rough paper
For a textured effect, choose rough paper. It can be tricky to render precise detail on this kind of surface, but it is suitable for loose, gestural drawings.

Broken, textured marks are produced with pencil on rough paper.

Charcoal pencil on rough paper has an interesting, granular quality.

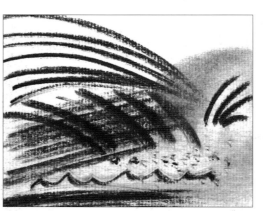

Toned paper
The paper hue itself will provide the midtone color or value. When working on toned paper, you will need to consider which medium to use for extreme highlights. Chalk, a white colored pencil, or a white pastel are good options.

Here a 2B pencil is used on toned paper.

Here charcoal is used on toned paper.

Drawing techniques

To make your monochrome drawings more exciting, as well as realistic, you will need to master a variety of techniques. Here you will see how to create interesting effects in a simple, still-life subject by using a combination of methods.

DIAGONAL HATCHING AROUND A SHAPE
The shapes are to be left white, so begin by diagonally hatching around them in any direction you please.

BUILDING UP TONE
Now darken the areas around the reserved shapes by making crosshatching lines in the opposite directions.

CURVED HATCHING
Use curved, parallel lines to describe the form or surface direction of objects.

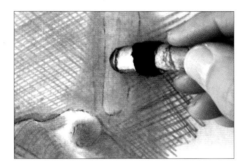

BLENDING WITH A STUMP
Hatch a few lines first, then rub them softly with the stump, blending areas of even tone for a smooth effect.

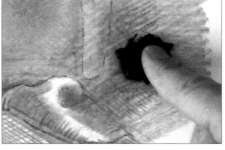

RAG BLENDING
Similar to the results achieved with stump blending, this technique covers a larger area. Ideal for cloud effects.

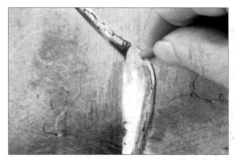

LIFTING OUT HIGHLIGHTS
Use your eraser to bring out strong highlights in your work.

PUTTING IT ALL TOGETHER
A quick sketch of a discarded boot and shovel includes all the mark-making techniques explained above.

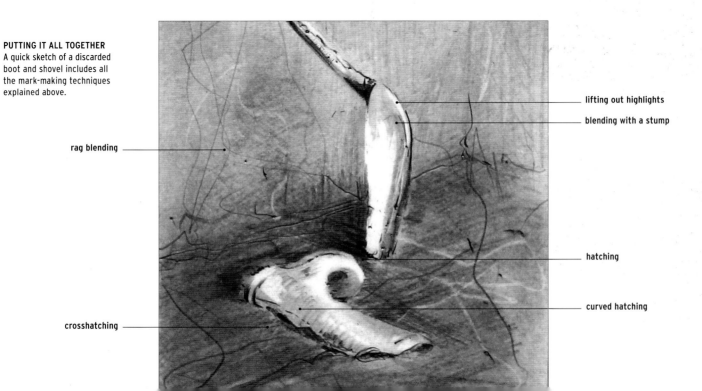

rag blending

crosshatching

lifting out highlights

blending with a stump

hatching

curved hatching

Using different marks

Even if inspired by the same object, no two artists will produce the same composition. Different approaches confirm that there are countless ways to capture the essence of something. Although both pairs of artists have reproduced faithful likenesses of their subjects, their choices of technique reflect differences in style, experience, and artistic vision.

Subject 1

In the first drawing, Artist 1 has used a small range of pencils and a light touch, relying mainly on line to describe the figures. In the second drawing, a wider range of pencils has been used, as Artist 2 takes a tonal rather than a linear approach.

ARTIST 1 ADRIAN BARTLETT

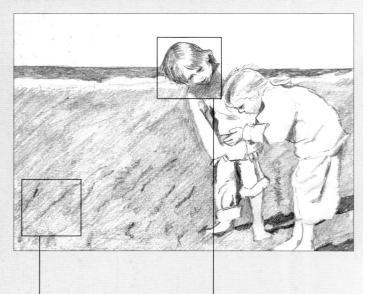

ARTIST 2 DAVID POXON

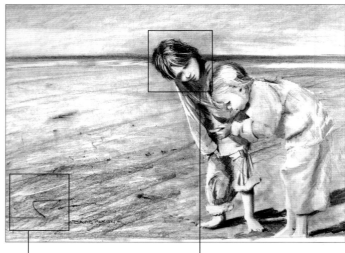

The area of sand is treated lightly, with diagonal hatching strokes of an HB pencil overlaid with shorter marks made with a 2B pencil.

The young boy's hair is drawn with curving, directional strokes, and the forms of the face are built up with gentle hatching and shading.

In this drawing, the area of beach on the left is given extra emphasis, with strong, diagonal hatching strokes leading the eye toward the figures.

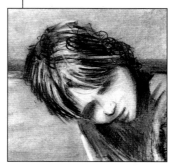

Strong tonal contrasts have been used in the hair and beneath the face using a 4B pencil. Highlights on the hair, which describe the form of the head, have been lifted out with a kneaded eraser.

TURNING YOUR PAPER AROUND
Rotate your piece of paper so it is now upside down and hatch in any areas to be shaded. Notice how the change in angle encourages a more varied and exciting result in your work.

Subject 2

In the first example, Artist 1 has contrasted long, sweeping strokes and firm hatching with loose squiggles. In the second example, Artist 2's use of lighter marks and blending methods creates an airy feel.

ARTIST 1 DAVID ARBUS

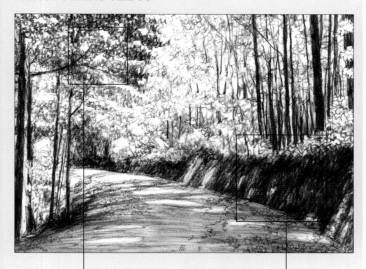

ARTIST 2 RICHARD MCDANIEL

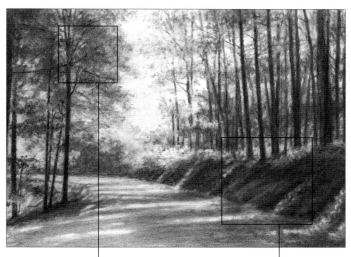

Multiple squiggle patterns in charcoal pencil create the illusion of dense foliage.

Dark, vertical hatching indicates the steeply sided bank in shadow.

The rag blending method and soft charcoal tones suggest forest mist.

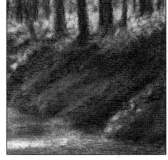

Hard, dark verticals applied over a hazy backdrop help separate the foreground and background.

Sketching

Practice makes perfect. Get into the habit of sketching as you watch television, sit in a park, or walk around the neighborhood. You do not need much equipment. Simply collect information and make quick studies, all the time coaching your mind to look at the world through the eyes of an artist.

Choosing a subject

Selecting what to draw when there is such limitless choice will depend on your interests and circumstances. Try to sketch from life as much as possible. Day trips, vacations, and visits to friends present valuable sketching situations. Your subjects don't have to be grand themes; they can be a quiet corner, a barn, pots on a table, or a favorite pet fast asleep. Sketch daily to train your eye. Above all, enjoy your journey of artistic exploration and discovery.

WINDOW AND BENCH
Record as much as you can about an outdoor subject before making a more detailed sketch at home. Here an old bench under a window is captured with a few lines and some shorthand notes.

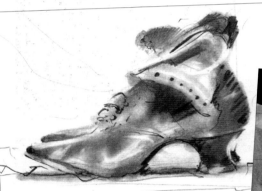

VICTORIAN SHOE
Shoes are complex objects and will test your powers of observation.

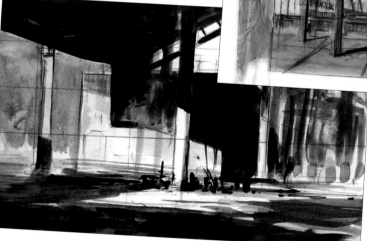

IRONWORKS
This old workplace where iron was once smelted provides an opportunity for practicing tonal drawing. This sepia ink sketch could just as easily have been done in pencil.

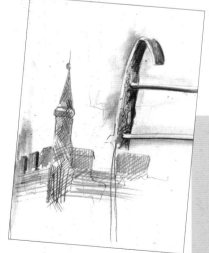

ZENNOR CHURCH
Old buildings and individual architectural details provide good sketching opportunities. Take in the whole scene or capture separate components as the artist has done here.

SKETCHING THE GREAT OUTDOORS
Capturing nature's changing moods in quick, shorthand sketches is a rewarding and stimulating pastime. To travel light, pack only a small sketch pad, two or three pencils, and an eraser. For more considered work, and when transport is not an issue, add larger paper and a drawing board to your basic kit.

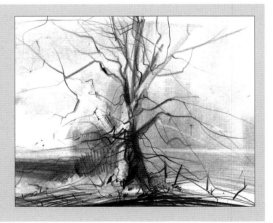

Choosing sketching techniques

Capturing the essence of your subject quickly is important, especially on outdoor sketching trips. Knowing the right technique to help you achieve the effect you want is key.

BLENDED MARKS
Random marks, some blended with a stump or rag, simulate an old, textured wall with a nail and dangling pieces of string.

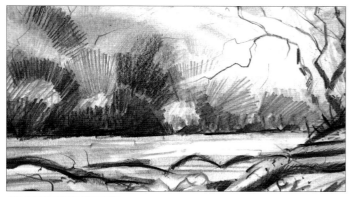

MULTIDIRECTIONAL HATCHING
Try to see the trees in the distance as massed shapes. In this instance, B and 4B pencils, combined with a variety of angled hatching strokes, are used to quickly record this river scene with its distant forest bank and fallen trees in the foreground.

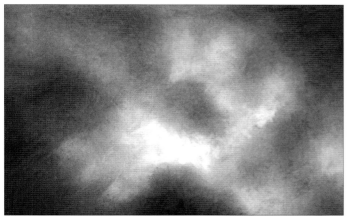

USING POWDERED GRAPHITE
The artist has used a graphite-covered rag from previous sketching sessions to suggest scudding cloud shapes in a moody sky.

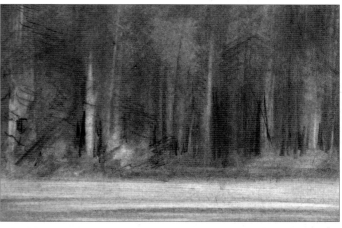

LIFTING OUT HIGHLIGHTS
The artist has used a plastic eraser to pull out highlights from both the water and the trees.

IDENTIFY POSITIVE AND NEGATIVE SHADOW PATTERNS

As we develop creatively, the world becomes a new and intriguing place. Illuminated by the light around us, we learn to see tonal contrast: shape against shape, light against dark, and vice versa. Learning to weave positive and negative shapes together to describe nature's intricate patterns is one of art's greatest achievements. In this sketch of kitchen chairs (right), the one nearest the viewer is silhouetted against the light as a positive image. Against the shadowy wall beyond, the opposite chair stands out, not as a silhouette, but as a series of light-against-dark shapes. Study the shadow patterns in all of your chosen subjects.

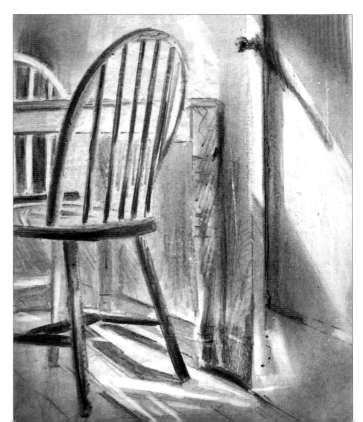

DRAWING PRACTICE
On days when bad weather keeps you indoors, you need only look around the house to see that there are plenty of drawing opportunities. The kitchen, for example, is a good source of subject material. Sketch at different times of the day, and observe how the changing light affects the different rooms of your home.

Capturing tonal values

Tonal value refers to how dark or light something looks relative to a light or dark area. The white of your paper represents your lightest tonal value, so any dark marks will create an area of high contrast. Gray areas establish "midtones" or "midvalues." It is tone rather than color that affects the realism of a scene: for example, a black-and-white photograph instantly jumps out at you without any need for color. Because the world offers us an infinite range of tonal values, artists often simplify what they see by limiting their tonal scale to five or six values.

Rendering a colored subject in monochrome

Before beginning, it is vital to identify the main light and dark tones. It also is helpful to squint your eyes, as this cuts out much of the detail and reduces the impact of color.

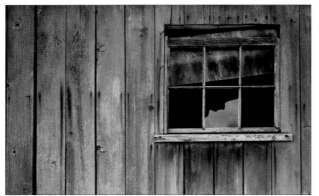

COLOR PHOTOGRAPH
This weatherworn wood cabin is a perfect example of the varied tonal shifts in potential subjects that we see around us. Try to see tonal values and their relationships to one another, rather than the colors.

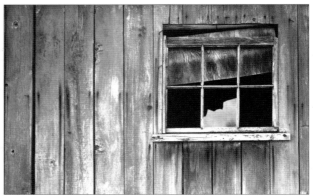

BLACK-AND-WHITE PHOTOGRAPH
This converted monochrome image makes it easy to see the tonal scale of the subject. Mid-value grays frame the dark, heavy window, and extreme highlights complete the tonal range.

Full tonal sketch

A full range of tones using B, 2B, and 4B pencils makes for an effective and realistic rendering of this old log cabin. Note the extreme contrast of the heavy darks against the white paper of the window area. This demands the viewer's attention first.

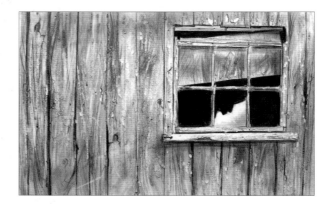

Tonal scales

Pencil drawings typically are lighter in appearance than charcoal drawings, but a range of tones can be achieved with both media.

Pencil tones A five-stage tonal scale using H, B, 2B, and 4B pencils.

Charcoal tones A five-stage value range in charcoal pencil.

Tonal practice

You can look at a black-and-white photograph and instantly know what it depicts without the need for color. To capture realism, understanding tonal value is key. To do this, transpose your scene into the three key value areas: high key, where all the dominant tones are light; midvalue, where tones are mostly "gray" and close together; and low key, where heavy darks emphasize the focal areas. Art with a close tonal value range gives a peaceful impression, whereas a greater contrast will make something appear more dramatic.

Original subjects

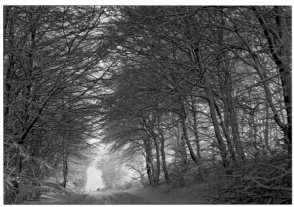

MIDDLE TONES
This wintry scene offers a mid- to high-key value range. Try rendering it without any extreme darks.

Tonal exercises

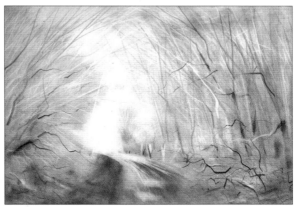

BLENDED MIDDLE TONES
Most of the image has been described in pale, soft tones to suggest a stretch of road under winter snow.

A FULL TONAL RANGE
Notice that all kinds of values are present in this image. To render the subtler shifts in shading, restrict your tonal range from mid- to high-key values.

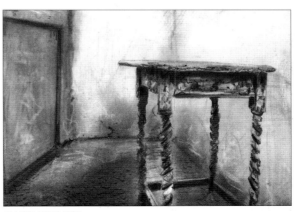

PLACING THE DARKS
In this mix of light, mid-, and a few well-placed dark tones, the dominant values are still in the middle range.

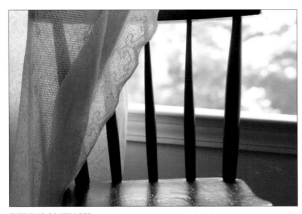

EXTREME CONTRASTS
This subject stretches the tonal register across a full range of values with the white-out background and silhouetted chair spindles at the two extremes.

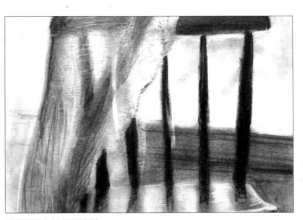

SOFTENING DARK TONES
The lace-drift curtain gives the mid- and light values. The tones of the dark chair are softened by the delicate spindle reflections.

Lighting

Light makes our world come alive. The same scene seen at different times of the day can range from bland to dramatic. Long, early morning or late afternoon shadows stir our senses, and sunrays trying to break through a mist-filled sky are atmospheric and moving. Record these priceless moments in your sketchbook.

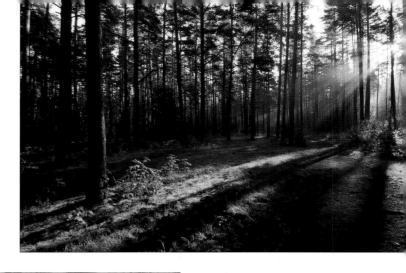

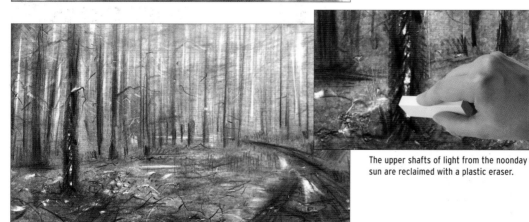

When working outdoors from life, make sure you establish the lights and darks quickly, before the light changes. Here a 2B pencil is held in the pressure grip to render the rich darks of the light-struck tree trunk.

DAWN
Early morning light illuminates a hazy forest. The strong light source in the upper right-hand corner of the photograph almost "melts" the trees, casting long, horizontal shadows across the picture plane.

The upper shafts of light from the noonday sun are reclaimed with a plastic eraser.

MIDDAY
The scene is transformed by natural light overhead. This same view of the forest, with dramatically different lighting, gives the artist the option of including more detail. Note the lack of cast shadows, which are now replaced by a more ambient, lower midtone.

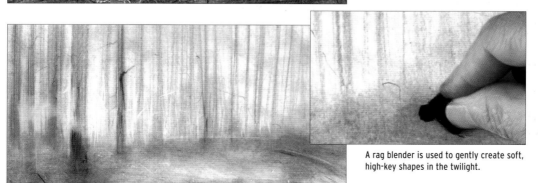

A rag blender is used to gently create soft, high-key shapes in the twilight.

DUSK
Soft evening light, with a touch of mist, creates a quiet, tranquil atmosphere, with detail and tonal contrasts much reduced. The light is not strong enough to produce shadows, though the low sun does pick up some foreground detail.

Interior lighting

When you want to draw a still life or capture an interior, the lighting requires some thought. If you are in control of the light source, which may be just a cheap spotlight, you can manipulate mood and drama. Experiment with arranging your light source so it comes in from different angles. Notice how the shift affects the form and atmosphere of your arrangement.

SUBJECT UNDER ARTIFICIAL LIGHT

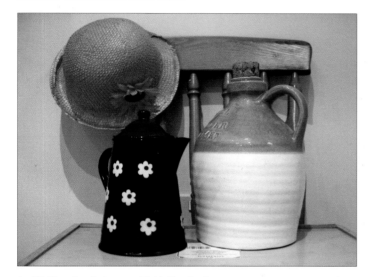

A still-life setup before spotlight illumination.

LIGHT SOURCE COMING FROM THE LEFT

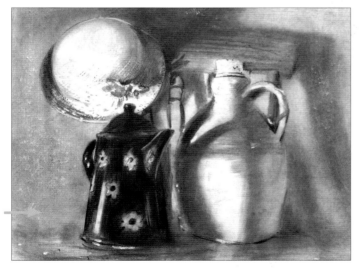

With the light source to the lower left, the effects are more dramatic. The coffee pot casts shadows across the earthenware jug that not only describe forms but also link the objects.

LIGHT SOURCE COMING FROM THE RIGHT

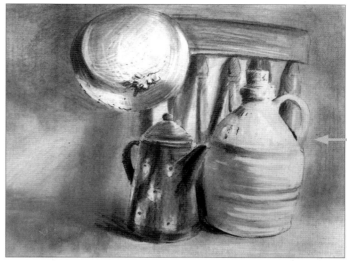

A single spotlight positioned to the right of the composition casts shadows from right to left across the subject.

LIGHT SOURCE COMING FROM OVERHEAD

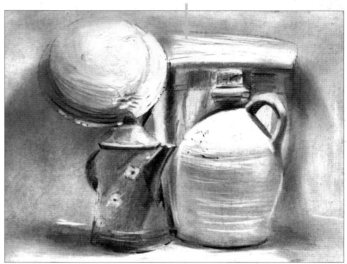

With the light source directly above the objects, top highlights are illuminated, but little form is noticeable.

NATURAL AND ARTIFICIAL LIGHT

Sunlight pouring into a room produces the most beautiful, natural effects in a complete contrast to those achievable with artificial lighting. But natural light is fleeting and ever-changing, so sketch your shadows and highlights quickly. You may even want to photograph your outdoor subjects so you are aware of the shifting tones and shadows.

Perspective

The real world is three-dimensional, but a drawing is two-dimensional. Depicting distance and proximity on a flat surface has challenged artists since the fifteenth century. Now we know of several ways to convey depth of field. One-point perspective creates the illusion that similar-sized objects get smaller as they recede into the distance. To suggest this, simply direct all converging lines toward a vanishing point on the horizon line (your eye level). Two-point perspective is another way of rendering changes in plane or direction by placing two vanishing points on the horizon. Aerial perspective describes how distant objects appear hazy, pale, and indistinct. By combining perspective techniques, your work will achieve greater depth and realism.

Measuring your subject

There are various systems for scaling or measuring your work. The most basic method involves holding your pencil (or ruler) at arm's length as you squint at your subject with one eye. Now move your thumb along the pencil shaft to "measure" the distance in scale, and transfer this measurement to your paper. Keep checking its accuracy against other measurements taken in the same way.

MEASURING UP

Always measure your angles from the same standing position, as any changes in body posture will dramatically alter the angles that you are trying to find. For this reason, it is important to re-check your initial angles as you progress through your artwork.

Using an angle finder

A simple device known as an angle finder will help you place angled lines correctly on paper. Cut out two rectangular pieces of card measuring 6 x 1 in. (15.2 x 2.5 cm), and clip them together at one end so you can adjust the angle. With practice, you will be able to "measure" all the angles in your scene and accurately record them on your drawing surface.

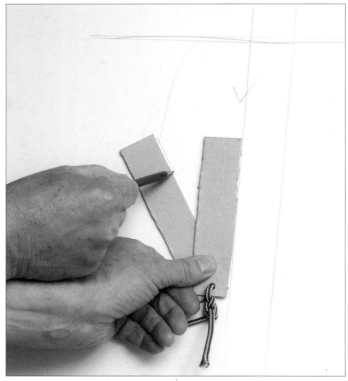

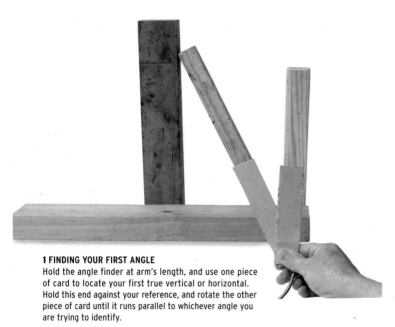

1 FINDING YOUR FIRST ANGLE
Hold the angle finder at arm's length, and use one piece of card to locate your first true vertical or horizontal. Hold this end against your reference, and rotate the other piece of card until it runs parallel to whichever angle you are trying to identify.

2 TRANSFERRING THE ANGLES TO PAPER
Having established the angle that you wish to find, firmly grip the pieces of card, so as not to "lose" this measurement, and transfer the pieces of card to your paper surface. Draw along the edge of your finder to pin down the position of your angled vanishing lines. Place the vertical card on your true vertical and simply draw along the edge of the angled card. You can repeat this process many times during your drafting session. Remember to keep re-checking your original angles, and make minor adjustments accordingly.

Aerial perspective

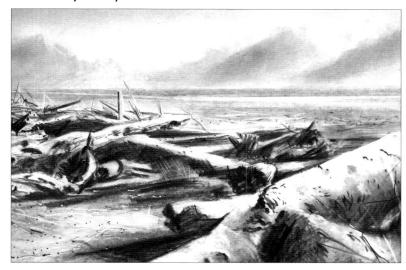

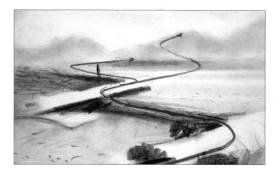

Aerial perspective refers to the fact that objects nearest the viewer appear clearer and more detailed than objects in the distance. This diagram illustrates this phenomenon, guiding the eye from the crisp foreground to the soft, subtle mountains in the distance.

One-point perspective

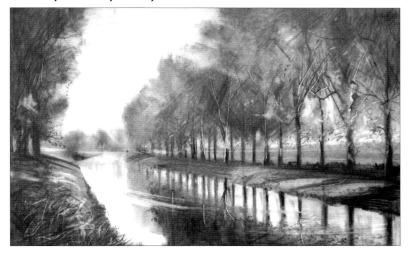

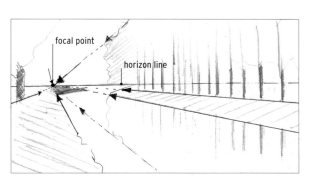

The diagram shows how all parallel lines, were they to continue, would finally lead to the vanishing point on the horizon. Note how even the top tree line roughly follows a line to this distant point.

Two-point perspective

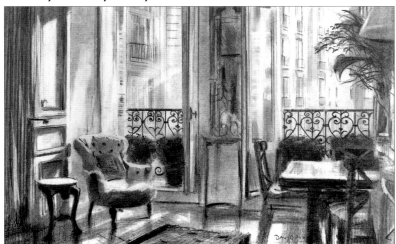

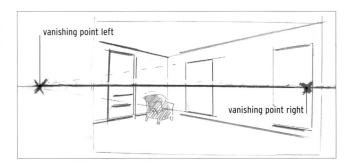

Quite often it is necessary to place two or more vanishing points on the horizon line to show directional changes in planes. Sometimes the points are positioned outside the picture plane. Here, one vanishing point is on the left; the other, for the left-hand wall, is on the right.

Composition

In art, the placement of key elements on paper can spell the difference between success and failure. Artists manipulate shapes with their tools to achieve a pleasing arrangement known as a "creative composition."

Making a classic viewfinder

A viewfinder is a simple tool to help you devise better compositions. Take a piece of cardstock and cut out a rectangular opening measuring about 4 x 2.5 in. (10.1 x 6.4 cm). Look at your potential subject through the aperture, and move the viewfinder until you locate the most inviting view to draw.

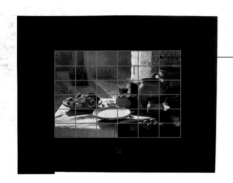

A more sophisticated viewfinder can be made by drawing a grid on transparent film and sandwiching it between the pieces of cardstock, as shown. This is helpful to work out the placement of subjects.

Making an L-shaped viewfinder

Alternatively, cut two 6 in. x 1 in. (15.2 cm x 2.5 cm) L shapes from the cardstock to give yourself the option of framing rectangular or square views. Larger L shapes can help you decide where the edges of your work should be. If it looks right, it generally is!

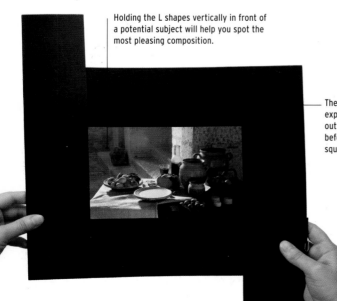

Holding the L shapes vertically in front of a potential subject will help you spot the most pleasing composition.

The two L shapes can be expanded or contracted to block out unwanted objects in the scene before you. Experiment using both square and rectangular formats.

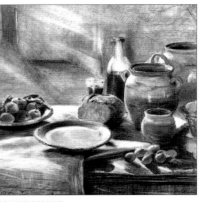

SQUARE FORMAT
This is a good format for some subjects, such as landscapes or portraits, and also could work for the still life. You would have to crop it at both edges, but you would be able to make more of the verticals in the composition.

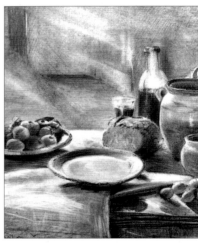

PORTRAIT FORMAT
This would involve even more severe cropping at the edges but would draw more attention to the central, empty dish and the verticals of the glass and bottle leading up to those in the background.

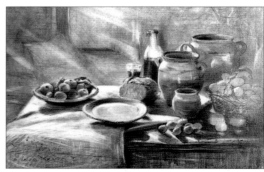

LANDSCAPE FORMAT
This is the most obvious choice of format for the subject, as it includes all the objects as well as the diagonal at the edge of the table, which helps lead the eye into the picture.

FRAMING YOUR WORK

It is worth investing in a few shapes and sizes of matt board from your nearest art supply store. Placing a matt frame around your finished work will instantly make it look more professional.

The theory of thirds

If you divide your paper into thirds and place your main subject near one of the points where two lines intersect, you may notice that your composition appears balanced and attractive. This theory applies to any format: portrait, landscape, or square.

INTERSECTING THIRDS

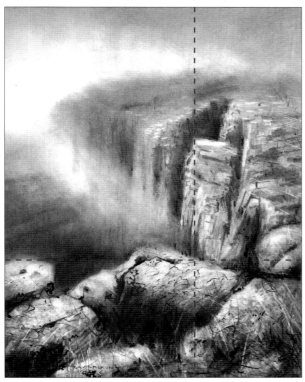

Center your focal points over intersecting thirds for maximum impact. The foreground is an important lead in to the main focal area, which is the section of vertical cliff. This area is emphasized first by placing the foreground edge and cliff over an intersecting third, and second by applying the darkest darks and lightest lights to these features, in close combination.

DISTANT FOCAL POINT

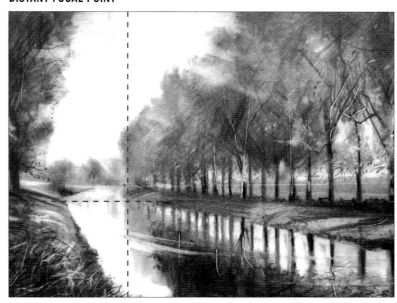

This landscape-format composition has a classic distant center of interest placed on an intersecting third. This scene combines aerial perspective with one-point perspective to lead the eye to its distant focus, the winding riverbank. This has been carefully placed over a vertical third to ensure the viewer retains interest and enthusiasm for the subject.

Scaling up

This process lets you enlarge any composition accurately without distorting the proportions. When you draw the grids, remember to number the rectangles or squares along the top and down one side for easy reference. Also, both grids should have the same number of rows and columns.

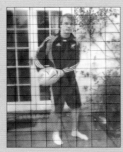

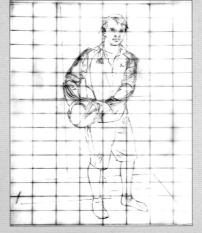

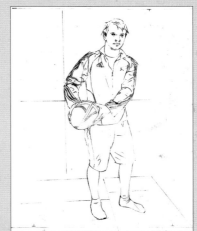

1 PREPARING THE PHOTO
Draw a grid of small rectangles on tracing paper over a photograph of your subject.

2 TRANSFERRING THE COMPOSITION
Draw a grid of larger, corresponding rectangles on your drawing paper. Use these grid lines to copy your composition onto the drawing paper.

3 CLEANING UP THE DRAWING
Erase the grid lines once the elements are in place. You now have an accurate enlargement of your subject without warped proportions.

Constructing the drawing

Although these charming drawings of a teddy bear and a violin are very different, both evoke a similar tranquil ambience. The techniques employed in both sketches stretch across the whole range discussed on the previous pages. Multiple tonal layering, blending with both stump and rag, and the subtle lifting out of key highlights all contribute to the pleasing feel of both studies.

The bear's face has been very lightly blended with a rag so that the pencil marks suggesting texture are still visible.

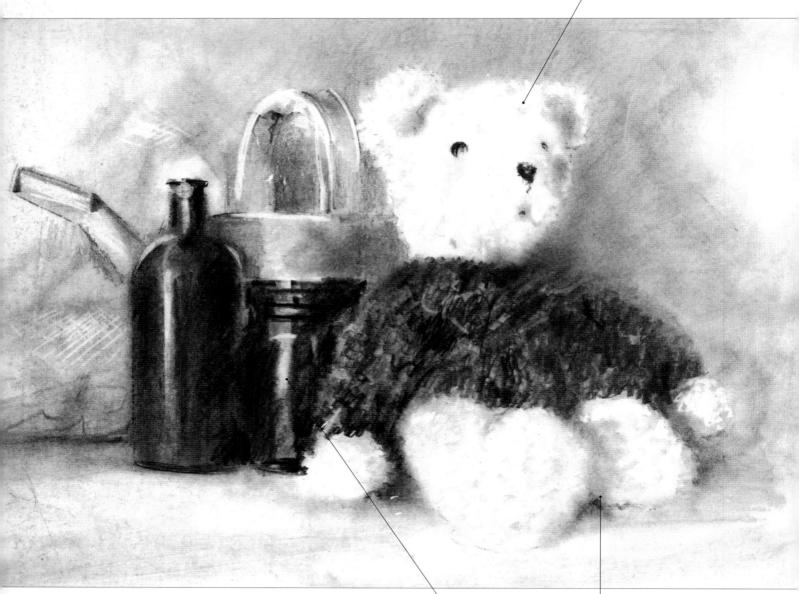

Teddy bear

With two glass jars and a watering can for company, the teddy bear is right of center with the line of his mouth intersecting a horizontal third line. Lighting is an important consideration, with both a single spotlight and daylight contributing significant contrast to the scene. An initial faint outline of the compositional elements is followed by layers of blending using B and 2B pencils.

The vertical highlights on the glass jars are made by erasing through any of the rich darks made with a 4B pencil. Note the tonal variety in these reflected surfaces.

Rendering the bear's fur involves the delicate application of graphite to loosely follow the curls with various controlled scribbles. These are then softly blended with a torchon.

Hatching strokes applied in different directions have been blended and then overlaid with further layers, building up a lively surface that adds interest in this area.

The violin has been positioned over a vertical third line, the dark sound holes on its body drawn over an intersecting horizontal third. This compositional combination achieves maximum impact.

The texture of the old, crumbling wall has been suggested by first indenting small, random marks and then layering and blending over them.

The square shape on the wall plays an important part in balancing the weight of the violin, as well as bringing in a touch of interesting texture.

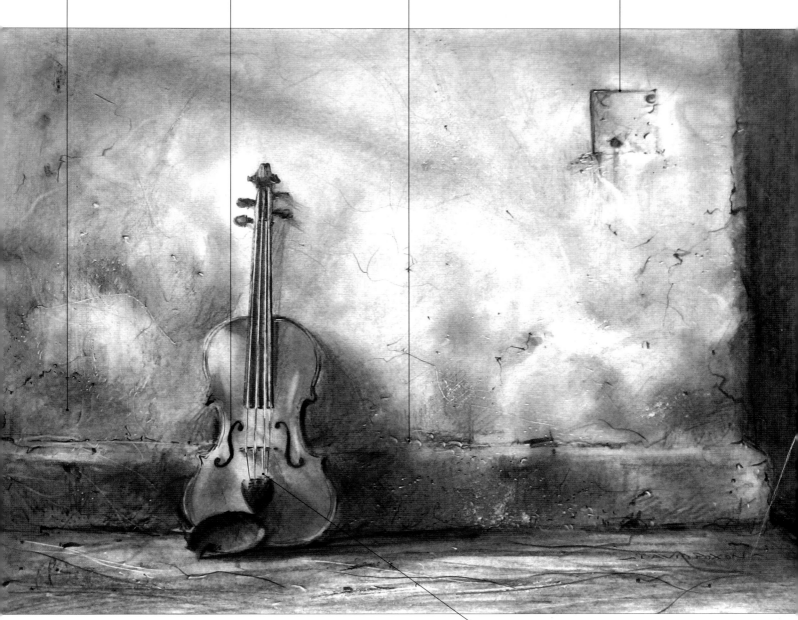

The four strings (seen as white in the drawing) have been made by first impressing straight lines with an incisor tool, then shading over the neck area of the violin.

Violin

In this evocative study of a classical string instrument leaning against a heavily textured wall, the contrast between surfaces has been emphasized using shading over impressed marks, followed by circular rag blending. The violin has received more accurate blending with a stump, and delicately lifted highlights have been gradated into any surrounding right and mid-tonal values.

Exploiting the tonal range

These two drawings achieve a sense of drama by having their subject placed against backgrounds that have the lowest tonal ranges. Although the subjects are very different from each other, the treatment of their surroundings is similar. The heavy darks are not merely one tonal value. There are several layers of graphite built with crosshatching and blending combinations using B, 2B, and 4B pencils. Faint outlines of unseen objects are left as suggestions to add mystery.

The highlights on the apples do not necessarily have hard edges. To get this effect, gently blend away from an erased area to achieve the required gradation.

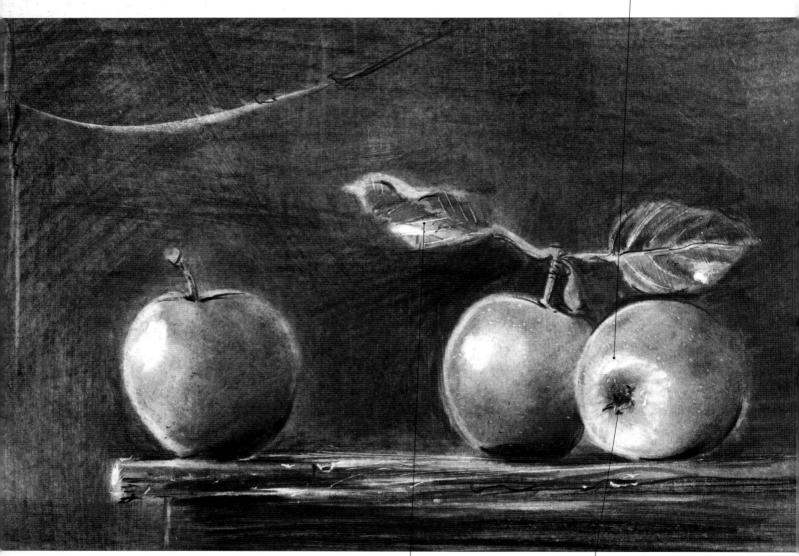

Apples

The apples first were rendered with curved hatching strokes that follow their forms. The light comes from the top left, so the areas of darkest darks are on the opposite side. Notice that on the area where the shadow side of the apple meets the background, there is a suggestion of a highlight.

The incised lines for the veins of the leaves were made at the start of the drawing and subsequently overlaid with more graphite before highlights were lifted out with a plastic eraser.

See how the effect of a hollow dip in the surface has been achieved by rendering several tonal values in close harmony, culminating in a stab of dark with a 4B pencil and several stippled areas.

The wooden step has been given texture by incising along the grain. It is an important part of the composition because it forms an opposing horizontal to the verticals of the spokes.

After placing the spokes with an outline, the paper surface is incised to follow the grain of the wood.

The segment of wood placed diagonally across the top of the picture echoes the one at bottom left and emphasizes the sweeping curve of the wheel by contrast of shape.

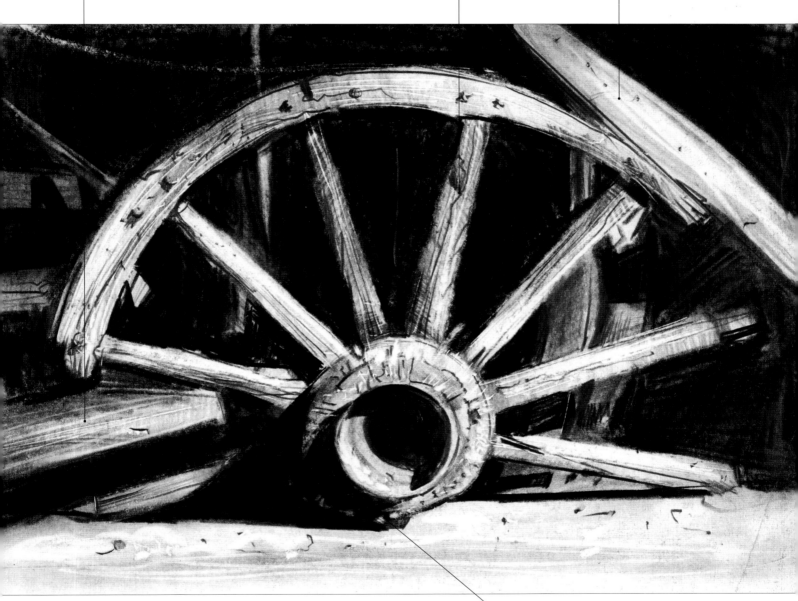

Wagon wheel

This atmospheric subject relies on bright light from the right to cast extreme shadow shapes. A careful rendering of the wheel rim and spokes, particularly the ellipses of the hubs and shadows, is vital in retaining authenticity and accuracy. Multiple textural effects are used to convey the appearance of weathered wood. Hatching, blending, incising, and erasing combine to depict this realistic image.

The dark shadow area across the weathered wood of the hub is a vital landmark in the drawing. The accurate placement of shadows gives the piece its almost three-dimensional effect. For interest and variety, some shadow edges are hard, and some have been blended into soft midtones.

A VACATION SETTING Richard McDaniel
pages 36–41

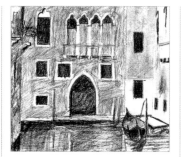

WAITING GONDOLA Adrian Bartlett
pages 42–47

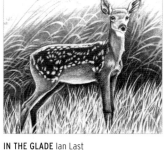

IN THE GLADE Ian Last
pages 48–53

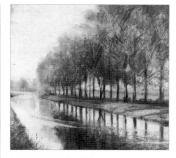

A QUIET PLACE David Poxon
pages 54–59

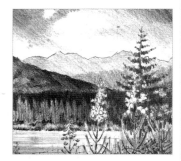

MORNING LIGHT Tim Nash
pages 36–41

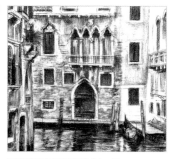

VENETIAN BACKWATER John Glover
pages 42–47

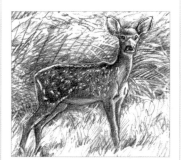

DEER IN THE LIGHT Peter Partington
pages 48–53

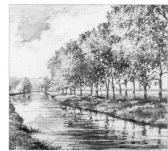

REFLECTIONS Martin Taylor
pages 54–59

Comparing

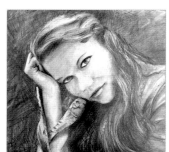

A GIRL LIKE YOU David Poxon
pages 84–89

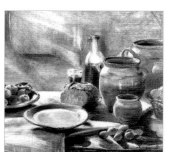

WOODLAND PATH David Arbus
pages 90–95

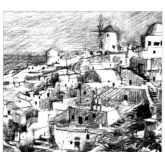

EXPECTING COMPANY David Poxon
pages 96–101

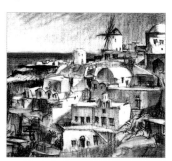

MEDITERRANEAN VILLAGE Martin Taylor
pages 102–107

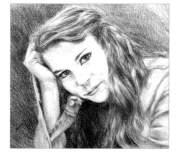

PORTRAIT OF A YOUNG WOMAN John Glover
pages 84–89

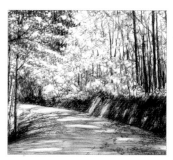

A WALK IN THE WOODS Richard McDaniel
pages 90–95

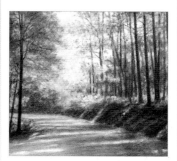

A FRUGAL LUNCH Myrtle Pizzey
pages 96–101

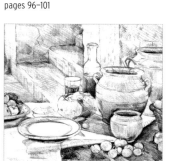

THE HILLTOP VILLAGE Ron Law
pages 102–107

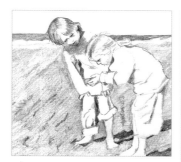

THE DISCOVERY Adrian Bartlett
pages 60–65

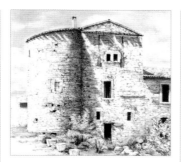

FERME AUBERGE Diane Wright
pages 66–71

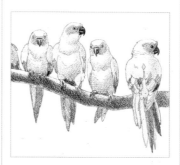

JUST PARAKEETS Peter Partington
pages 72–77

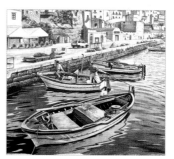

BRINGING IN THE CATCH Ian Last
pages 78–83

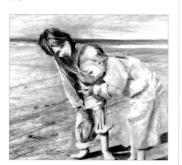

MAGIC TIME David Poxon
pages 60–65

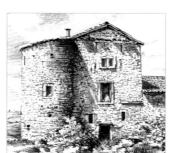

FRENCH FARMHOUSE Martin Taylor
pages 66–71

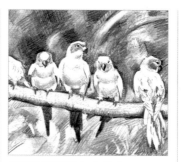

PARROTS Philip Snow
pages 72–77

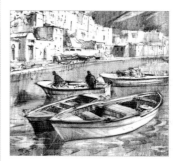

AT THE HARBOR Ron Law
pages 78–83

techniques

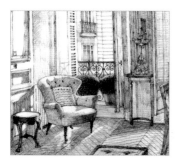

CITY INTERIOR David Arbus
pages 108–113

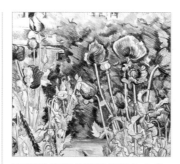

PAPAVERS IN THE EVENING LIGHT Myrtle Pizzey
pages 114–119

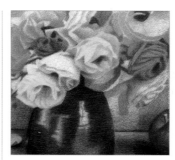

SUMMER ROSES Peter Woof
pages 120–125

It is time for our professionals to go head to head. Not only are the subjects extremely varied, but the techniques and compositional decisions used result in some wonderful variants of style and mood. Reach for your drawing kit and follow every move that our artists make as they bring these enticing subjects to life.

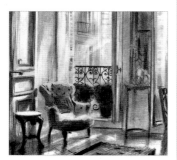

YOUR CHAIR David Poxon
pages 108–113

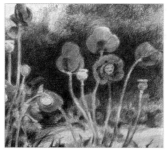

BLOSSOM PARADE Richard McDaniel
pages 114–119

ROSES AND APPLES Robert Maddison
pages 120–125

Lake and mountains

This expansive landscape can be approached in myriad ways. The artists must decide how best to establish a sense of depth, simplify the scene to make it manageable, and create a center of interest. Artists Richard McDaniel and Tim Nash choose two very different approaches to render the scene in graphite.

Materials
2B pencil
4B pencil
6B pencil
Kneaded eraser
Paper towels
Cold-pressed drawing paper

Techniques
Composition, pages 28–29
Perspective, pages 26–27
Holding a pencil, page 12
Crosshatching, pages 13 and 17
Blending, page 17
Lifting out highlights, page 17

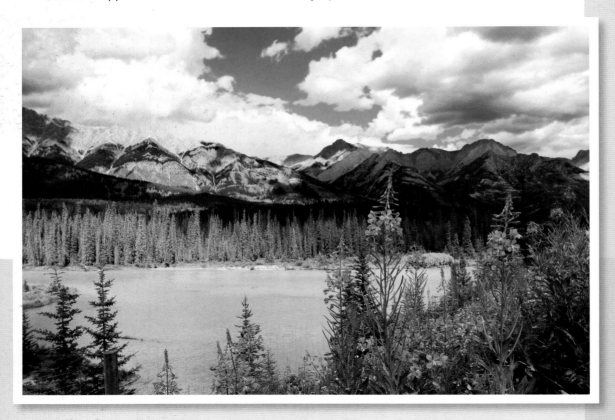

CREATING A FOCAL POINT
This photograph has many interesting elements (clouds, mountains, lake, trees, flowers) but no obvious focal point, so the artists must establish one. There are numerous ways to help draw the viewer's eye to a specific area, including cropping; creating contrasts in value, shape, or size; or juxtaposing horizontals against verticals. The ways in which artists choose to apply these techniques are what make each work of art unique.

Materials
2B pencil
6B pencil
9B pencil
Smooth drawing paper

Techniques
Composition, pages 28–29
Perspective, pages 26–27
Blending, page 17

ARTIST 1:
Richard McDaniel

Artist 1 usually begins with a linear sketch, as shown below, but for the finished drawing, he works rather as a watercolor painter would, gradually building up tones from light to dark and making use of blending methods in the early stages.

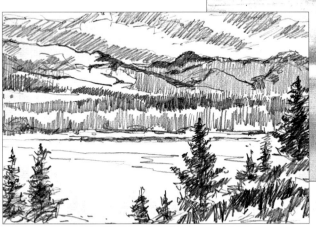

SKETCH
To familiarize himself with the subject, Artist 1 makes a quick sketch. He concentrates on organizing the value patterns.

1 SOFT TONES
With a 6B pencil, Artist 1 first scribbles on a piece of scrap paper, then rubs paper towel in the graphite and transfers smudges of graphite to his drawing surface. This produces a soft undertone on which he can build the composition.

ARTIST 2:
Tim Nash

Artist 2 takes a more traditional linear approach. Having made a sketch to organize the composition, he then draws firm outlines before blocking in and building up the tones gradually as the work progresses. He does not use much blending, as he sees the varied marks of the pencils as an important element in the finished drawing.

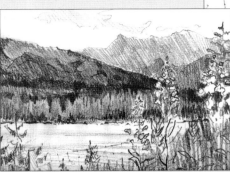

SKETCH
Artist 2 uses his sketch to reorganize the composition. He alters the height of the right-hand tree so it breaks through the mountain range into the sky. His drawing reveals adjustments that deviate from the reference photograph.

1 LINE DRAWING
Using a 2B pencil, Artist 2 draws in the basic shapes in line only, carefully working out where verticals cross horizontals. The intersection of these lines will be used to give his drawing the illusion of distance.

2 **BUILDING THE LANDSCAPE**
Using a 2B pencil, Artist 1 starts to block in the distant mountains. He draws around the horizontal line of the distant forest to create contrast. He then suggests shadows on the mountains with a midtone.

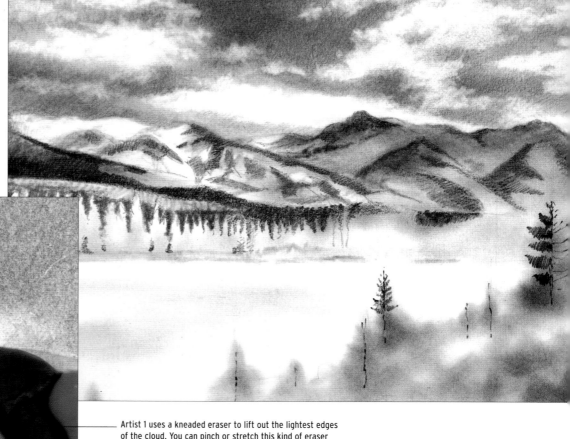

Artist 1 uses a kneaded eraser to lift out the lightest edges of the cloud. You can pinch or stretch this kind of eraser into a variety of shapes to reach small, precise areas.

2 **BLOCKING IN**
Using an angled stroke and a 6B pencil, Artist 2 blocks in the distant sky shapes, followed by the mountains. When blocking in the tree line, he uses vertical strokes, skirting around the flower shapes in the foreground.

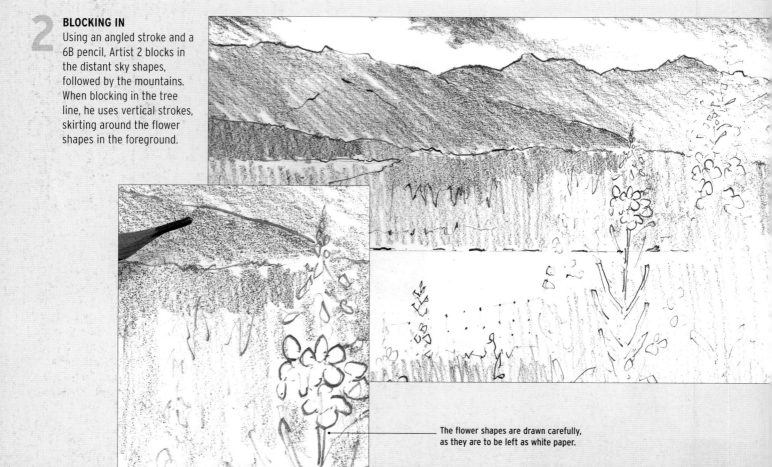

The flower shapes are drawn carefully, as they are to be left as white paper.

3 **STRENGTHENING VALUES**
Using the sketch grip, a 4B pencil, and the crosshatching technique, Artist 1 adds deeper tones to the drawing. He renders the foreground trees in finer detail.

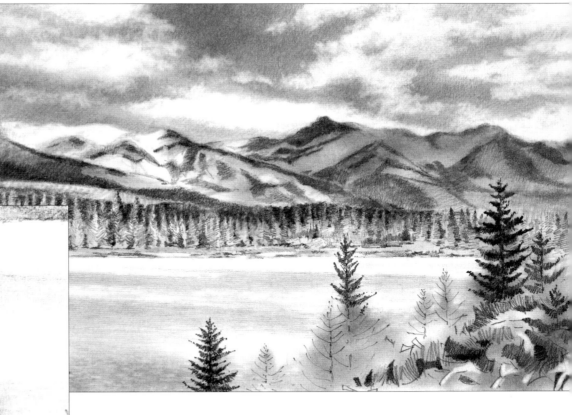

Using a sharpened pencil, Artist 1 defines the crisp edges of the foreground trees.

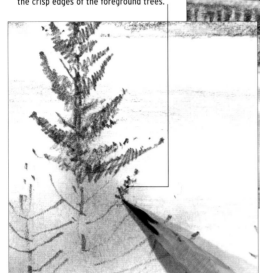

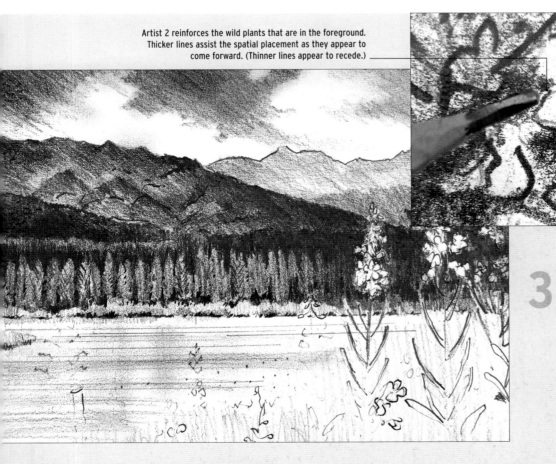

Artist 2 reinforces the wild plants that are in the foreground. Thicker lines assist the spatial placement as they appear to come forward. (Thinner lines appear to recede.)

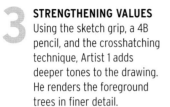

3 **MAKING MARKS**
With his 6B and 9B pencils, Artist 2 starts to stretch the tonal values by blocking in more darks around the flower shapes. He gently rubs distant edges with a finger to soften their forms. To create reflections of the sky in the lake, he drags graphite down vertically with his finger, from the forest edge into the clean area left for the lake.

FINAL STAGE

Artist 1 adds further detail to the pine trees, building up a rhythmic pattern of light and dark. The first pass of tone made with the paper towel is now completely covered by the overdrawing. Without the undertone, he would not have achieved the rich darks in the forest and mountains that give this drawing its sense of scale and distance.

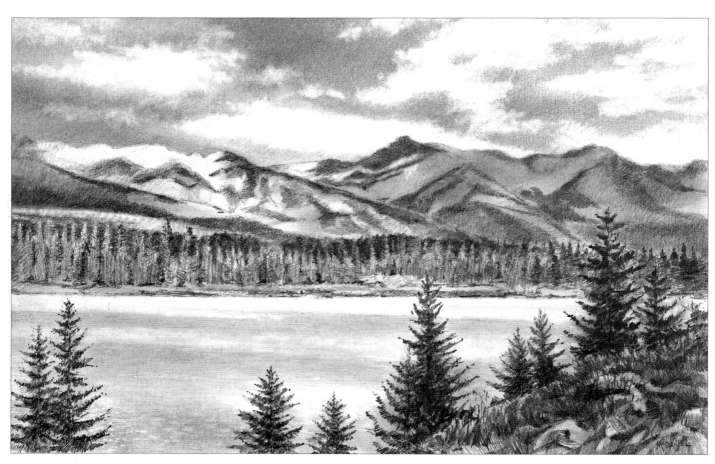

Soft, horizontal blends create the sense of a watery surface.

The mountain tops are treated with a mix of lost and found edges, which enhance the impression of aerial perspective.

A VACATION SETTING

(10 X 15 IN. / 25.4 X 38 CM, GRAPHITE ON COLD-PRESSED DRAWING PAPER)

"Whether direct from the pencil or manipulated with a rag or eraser, the delicate tones of graphite are well suited for describing this majestic vista. Pencils have long been a favorite medium of mine; they are so humble yet are capable of creating a variety of subtle marks such as the lake reflections and cloud-filled sky."

Richard McDaniel

FINAL STAGE

Artist 2 adds more darks to the nearest mountains. He emphasizes the various distance points in the picture plane by layering light tones against midtones and ultimately against extreme darks. Foreground areas are kept lively in contrast to the relative calm of the lake, and he uses the slight angle of post and fence to lead the eye into the landscape.

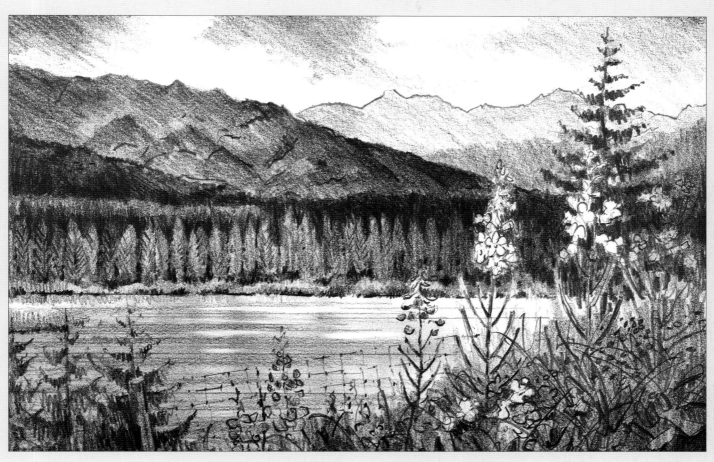

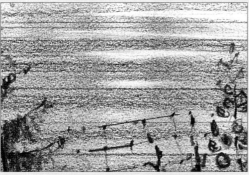

A textured lake surface gives the impression of a wild landscape under stormy skies. Notice how the tone of this texture appears to get darker as it gets closer. This is another perspective device.

Artist 2 has raised the mountains into the top third of the picture plane. This emphasizes their dramatic qualities, yet we are still aware that there is a vast distance in crossing the lake.

MORNING LIGHT

(8 X 12 IN. / 20 X 30 CM, GRAPHITE ON SMOOTH DRAWING PAPER)

"An atmospheric sky moves across the drawing as tonally layered mountains create perspective and distance. Large flowers, light against dark, dominate the trees of the mid-distance, while water shimmers through an old metal fence. Lost and found edges lend mystery."

Tim Nash

COMPARING THE WORKS

Although both artists are using the same medium, the two images create two very different atmospheres. The soft blends in the first drawing give a sense of tranquility, whereas the second has more drama, due both to the energetic, multidirectional pencil marks and the way Artist 2 has focused in on the center of the composition to emphasize the line of pale trees against the dark mountain.

Canal scene

These old Venetian houses are a challenge for Adrian Bartlett and John Glover. Although the one-point perspective is fairly simple, the foreground is somewhat featureless, so the artists must use their ingenuity to lead the viewer's eye into the scene. Both choose charcoal for this exercise, as its grainy texture is perfect for depicting the crumbling façades.

■ **Materials**
Medium-grade charcoal pencil
Scrap of cloth
Smooth drawing paper

■ **Techniques**
Perspective, pages 26–27
Composition, pages 28–29
Hatching, pages 13 and 17
Blending, page 17

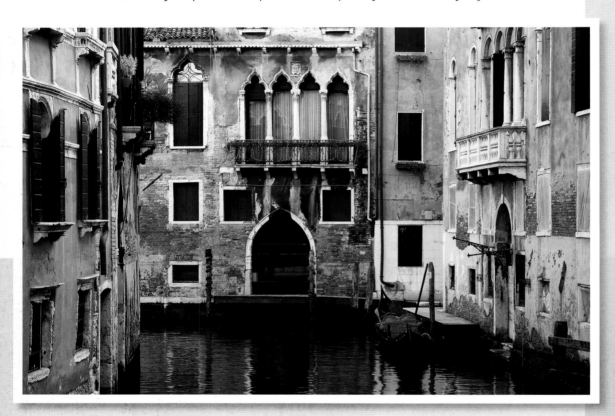

FOCUSING ON THE FOREGROUND
The foreground is an important feature of any landscape or architectural scene because it helps lead the viewer's eye toward the focal point (which, in this case, is the arched doorway and the four windows above it). To improve the foreground of this composition, an artist could emphasize the reflections in the water, elevate the importance of the gondola in the lower right corner, or increase the tonal contrast between the water and the buildings.

■ **Materials**
Willow charcoal stick
Medium-grade charcoal pencil
Dark charcoal pencil
Kneaded eraser
Blending stump
Cotton swabs
Smooth drawing paper

■ **Techniques**
Perspective, pages 26–27
Composition, pages 28–29
Blending, page 17
Scribbles and squiggles, page 13
Lifting out highlights, page 17

ARTIST 1:
Adrian Bartlett

Artist 1 uses loose, sketchy strokes with little blending or detail. He begins with the dark shapes of the doors and windows, lightly sketching in the converging parallel lines of the side buildings. He draws the shapes carefully: charcoal pencil is more difficult to erase than charcoal stick.

SKETCH
Artist 1 makes a rough sketch, concentrating on the geometric shapes created by the windows, arches, and doors.

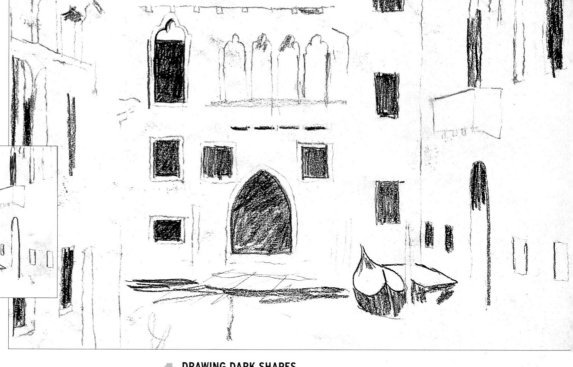

1 DRAWING DARK SHAPES
Artist 1 uses a medium-grade charcoal pencil to sharpen up some of the linework that places the main architectural shapes. He then begins blocking in the relative tones of the various windows and doors.

ARTIST 2:
John Glover

Artist 2 utilizes charcoal pencil and willow charcoal for a deeper tonal approach to this more precise, blended, and detailed drawing. Large areas of tone can be built up by using the stick on its side, though the process can get a little messy.

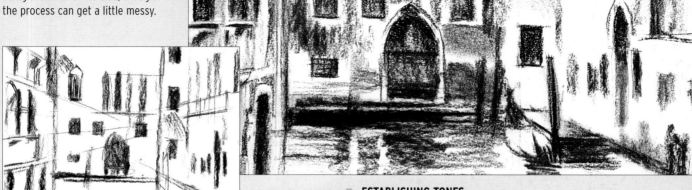

SKETCH
Artist 2 uses his preliminary sketch to work out the placement of perspective elements and vanishing lines.

1 ESTABLISHING TONES
Artist 2 draws the main lines with a medium-grade charcoal pencil, and then applies larger concentrations of tone with the willow charcoal stick. Larger areas can be covered more quickly using the side of the charcoal stick, but the process is not as clean as with a charcoal pencil.

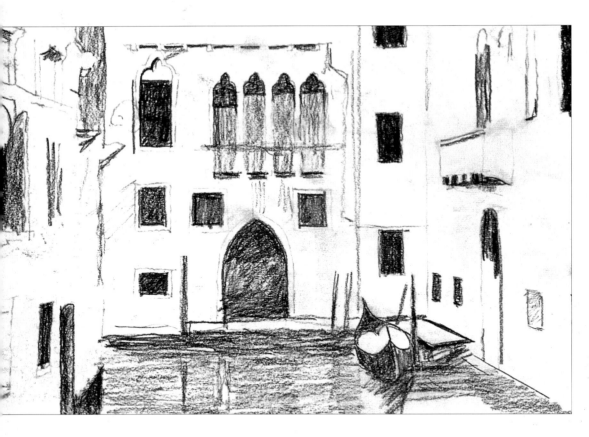

2 REFLECTIONS
Artist 1 turns his attention to the water, suggesting its slightly rippled surface by placing the building reflections. He uses only three tones at this stage, the lightest being the white of the paper.

2 BLENDING
Using a stump and cotton swabs, Artist 2 blends the areas of masonry. Both tools create similar results, but the swabs are disposable. Artist 2 then uses a kneaded eraser to reinforce and sharpen the highlights on the right-hand building, contrasting them with blended and unblended areas of charcoal to simulate the rough texture of the walls.

Artist 2 uses a dark charcoal pencil to sharpen up the darkest areas of reflection.

3 TONAL BLOCKING

To cover the central and left-hand buildings with a midtone, Artist 1 roughly hatches in the areas to be shaded, blending in places to create a contrast between the smooth and rough plaster, as well as the light and dark of the central arched door.

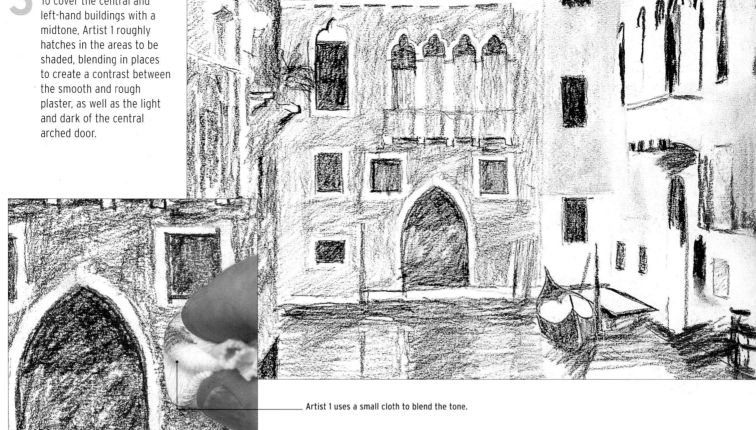

Artist 1 uses a small cloth to blend the tone.

Using a dark charcoal pencil, Artist 2 refines the intricate moldings on the balconies.

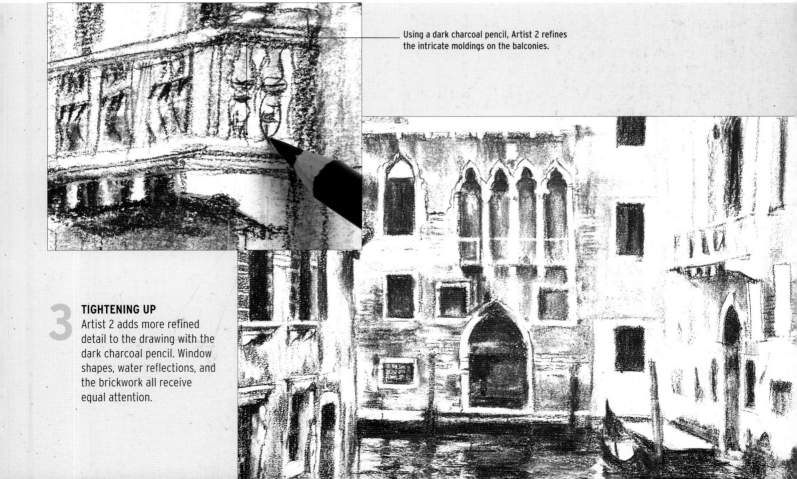

3 TIGHTENING UP

Artist 2 adds more refined detail to the drawing with the dark charcoal pencil. Window shapes, water reflections, and the brickwork all receive equal attention.

FINAL STAGE

Artist 1 reinforces the darks in some of the archways and tightens up some of the details. Compositionally, he has continued with the black-and-white patterning effect in the finished work. The buildings are supported by the dark water surface, and the main central arch provides the visual link between surfaces.

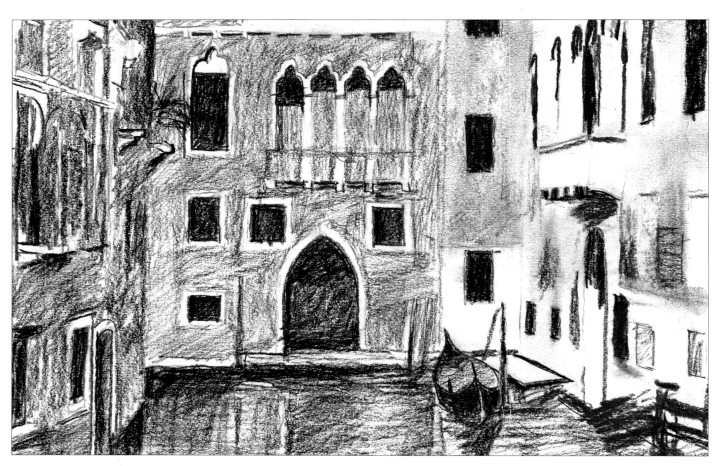

Artist 1 is not overly concerned with precise architectural detail. His focus throughout is the almost abstract balance of light against dark shapes. Notice that almost a third of the picture surface is left as white paper. This window detail is submerged in a dark shadow area of the left field two-thirds.

Artist 1 makes the buildings sit on an almost solid dark foundation. The reflections are very subtly suggested, but we still recognize this foreground as water, the visual clues being the few vertical reflections and the right-side boats.

WAITING GONDOLA

(7.9 X 11.8 IN. / 20 X 30 CM, CHARCOAL ON SMOOTH DRAWING PAPER)

"The first attraction of this scene is the wonderful pattern of the various window shapes. There is something mysterious about this corner of a Venetian canal with the moored gondola waiting for somebody to emerge from the crumbling palazzo. I hope to have conveyed this sense of mystery by darkening the building appearing on the left."

Adrian Bartlett

FINAL STAGE

Using a very sharp charcoal pencil, Artist 2 makes a final pass over all the architectural details. Some detail is added to the boat, and reflections are made with vertical zigzag markings. Note how the dark boat bow is contrasted against the white of the right-side building. This type of attention aids the three-dimensional perspective effect.

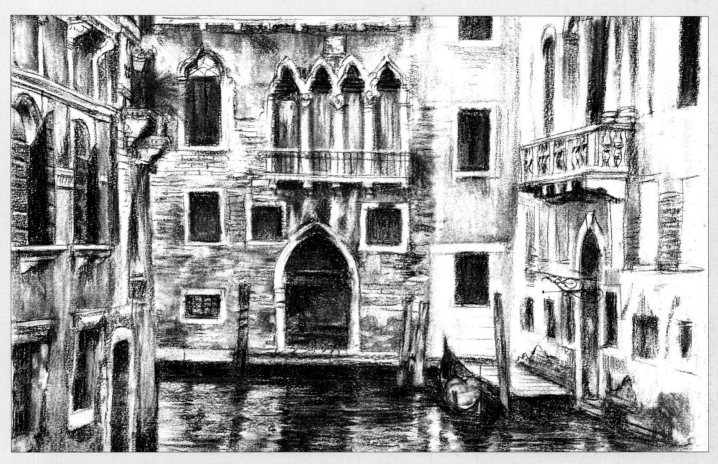

Artist 2 has observed the lintel and windowsill details accurately. These areas of the drawing reinforce the one-point linear perspective on which the composition is based.

The surface of the water is treated similarly to the surface of the buildings. The textural effects are made more by the crumbly charcoal than by any detailed linework. Broken surface lines are drawn horizontally across the picture plane and cut across the vertical building reflections.

VENETIAN BACKWATER

(8.5 X 11.8 IN. / 23 X 30 CM, CHARCOAL ON SMOOTH DRAWING PAPER)

"This scene was a fascinating challenge in linear perspective and proportion. Venice is associated with the magic of color, so I enjoyed trying to capture its atmosphere and character in black and white, in the texture and tones of its decaying buildings and the reflections and movement of the water."

John Glover

COMPARING THE WORKS

The two compositions are very similar, and both artists have given more impact to their drawings by suggesting a strong light hitting the right-hand wall. Artist 1 shows less interest in texture and architectural features than in the juxtaposition of shapes and has omitted much of the detail. Artist 2 suggests texture on the far wall and clearly enjoys the intricate balconies and arches.

Deer

Drawing an animal poses two main challenges for artists: to describe its form accurately and to convey that it is a living, breathing creature. Here artists Ian Last and Peter Partington both rise to these challenges, using graphite to illustrate the young deer's gentle yet alert expression.

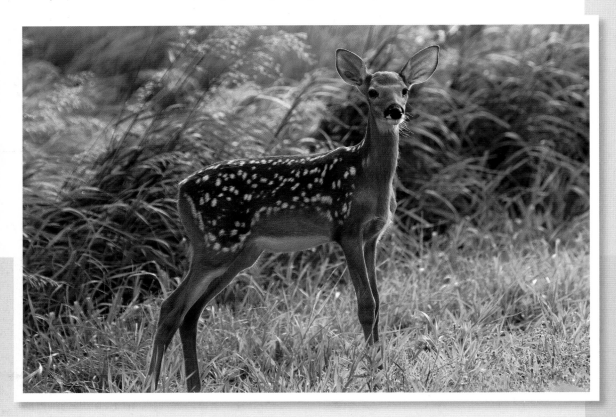

■ Materials
H pencil
B pencil
2B pencil
4B pencil
Incisor tool
Kneaded eraser
Smooth drawing paper

■ Techniques
Hatching, pages 13 and 17
Incising (impressing), page 13
Lifting out highlights, page 17

■ Materials
B pencil
2B pencil
4B pencil
Kneaded eraser
Drawing paper

■ Techniques
Crosshatching, page 13 and 17
Lifting out highlights, page 17

DEPICTING A DELICATE DEER

In this photograph, the grasses behind the deer are blown by the wind and help give a sense of life to the animal itself. But the way the animal is photographed, almost square to the viewer and lit from behind, makes it hard to see the forms, so special skills are required to ensure that it does not appear as a flat shape. There is little visible light or shadows on the body, but the pattern of spots gives an indication of form, as the spots fall around the body in a loose curve, becoming smaller at the top where they meet the backbone.

ARTIST 1:
Ian Last

Artist 1 begins with a linear sketch to establish the main shape and placement of the deer. He then makes a faint outline with an H pencil before working in tone to build up the forms. The placing of the head (the focal point of the drawing) is very important, and the eyes, nose, and mouth are rendered carefully.

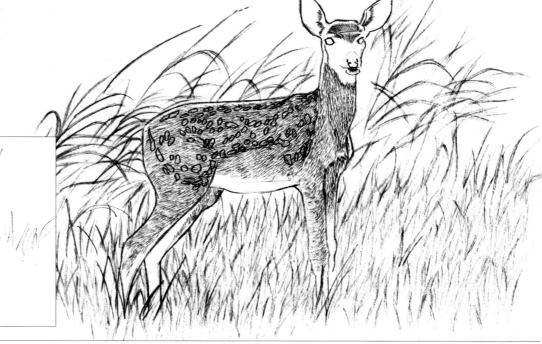

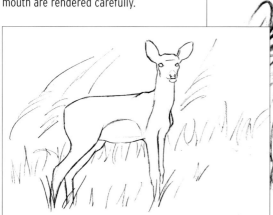

SKETCH
This line drawing shows the deer's simplicity of construction. The head shape fits into the width of the neck area, and the left neckline is nearly continued vertically to find the front right leg. The "kink" in the rear legs is an important feature.

1 LIGHT AGAINST DARK
Artist 1 uses tonal contrast (sometimes called "counterchange") to good effect in rendering the deer's rear legs. By leaving the far leg light against the dark near leg, he alters the reference image and provides the viewer with an important form indicator.

ARTIST 2:
Peter Partington

Unlike Artist 1, Artist 2 likes to work out the tonal pattern in a preliminary sketch rather than concentrate on the outline, as this helps him avoid making corrections later and gives him all the visual information he needs for the finished drawing.

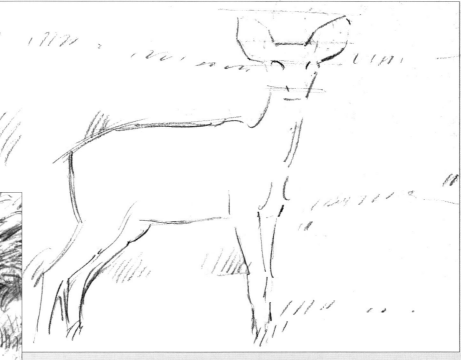

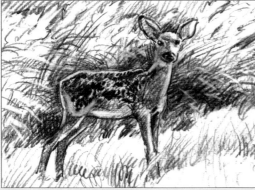

SKETCH
Artist 2's small study is vitally important because it promotes an understanding of the tones, shapes, and technical challenges of the subject.

1 STRUCTURE AND SHAPE
Artist 2 blocks in the main outline with a B pencil, overdrawing in places to correct some lines. Detail is of no concern at this stage, and only when the main lines are in place does he add the eyes and ears.

2 ESTABLISHING FORM

Artist 1 roughly hatches in the background with the H pencil and then begins working on the deer. He uses a 2B pencil to place the darker tones of the deer's back and a B pencil for the remaining form. The top of the head and neck are treated with lighter markings and left as a pale midtone. The white spots begin to stand out against the deep darks of the surrounding fur.

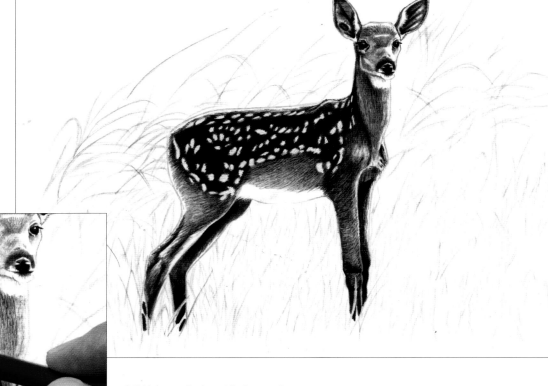

Artist 1 deepens the tone of the fur around the white spots with a 2B pencil.

2 FEATURES AND TEXTURES

Artist 2 follows the flow and direction of the grasses with his pencil strokes. He then uses the side of a 2B pencil to block in tone on the deer's body, and places the dappled spots on the flanks, being careful to follow the natural patterns of the subject. He pays special attention to the structure of the deer's brow and nose, as well as the area where its neck and torso join.

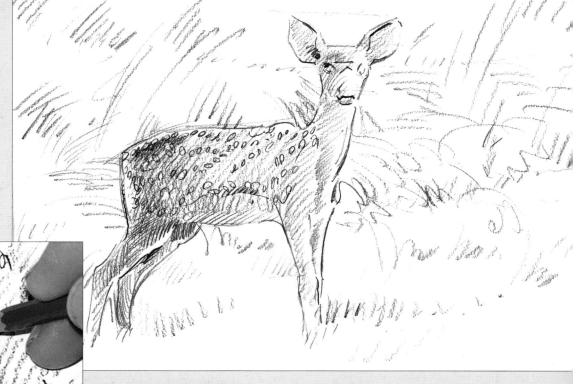

Artist 2 places the pattern of circular markings with care.

After impressing the background, further highlights are regained with a small kneaded eraser.

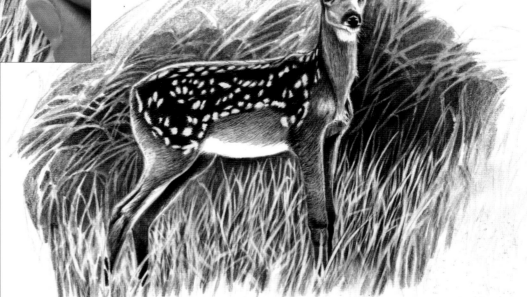

3 ADDING BACKGROUND

Artist 1 turns to the glade. He incises hard lines into the paper with an incisor tool, then sketches over the foreground with a 2B pencil and over the background with a 4B pencil. The indented paper now stands out as pale grasses against the darker pencil marks. Other grasses are retrieved with a kneaded eraser. There is a good mix of hard and soft edges in the vegetation.

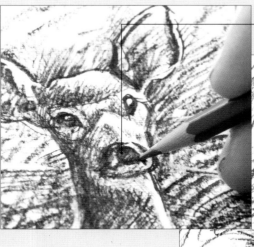

Artist 2 adds rich darks to the nose, which starts to contrast sharply with the lifted-out highlights.

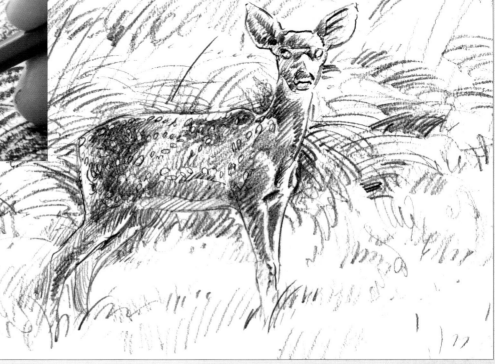

3 DETAILED DRAWING

Using a 4B pencil, Artist 2 adds more detail to the head and deepens the tones of the body and legs. Working more tone into the background, he keeps the foreground lighter to contrast with the dark grasses in the diagonal of the ditch. A kneaded eraser is used to lift the highlights.

FINAL STAGE

The deer is silhouetted against the light, so it needs to be brought forward, away from the background. Using a 4B pencil, Artist 1 darkens the areas around the deer. Then he adds more grass detail. Finally, he cleans up the white highlights on the body and in the vegetation with a kneaded eraser.

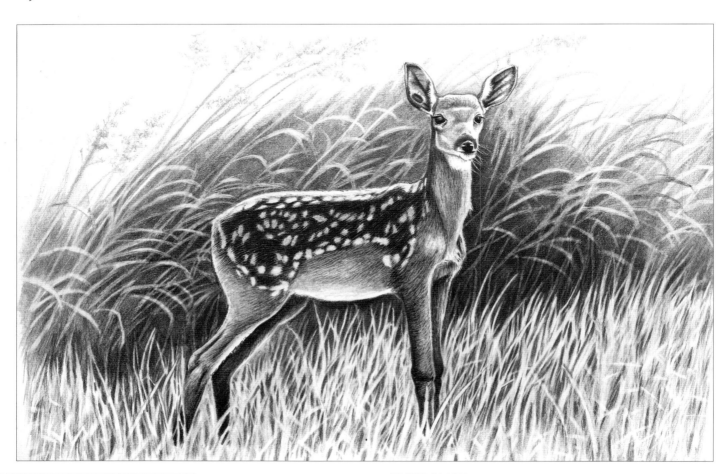

There is a clear delineation between the foreground and background vegetation. Vertical grasses echo the verticals of the deer's legs, but are rendered into the curving shapes of the more distant grasses, standing out as lights against the undergrowth.

The deer's underbelly shows subtle gradated graphite tones ending with a perimeter highlight similar to that on the deer's back.

IN THE GLADE

(7.5 X 10.6 IN. / 19 X 27 CM, GRAPHITE ON SMOOTH DRAWING PAPER)

"A feeling of strong light brings up scenes of a peaceful open meadow on a sunny day. I wanted to make this drawing about the deer and not have the background be too distracting, so it has elements of a study. Carrying the feeling of light into the grass in the background can be quite a difficult technique to produce with pencil but is well worth the time taken."

Ian Last

FINAL STAGE

Artist 2 starts to emphasize the edges where tonal planes meet to link the animal to its environment. The preserved whites along the deer's back and around its ears start to bring the deer forward. The nostrils and lower jaw are rendered to completion, and finishing touches are added to enhance the deer's inquisitive expression.

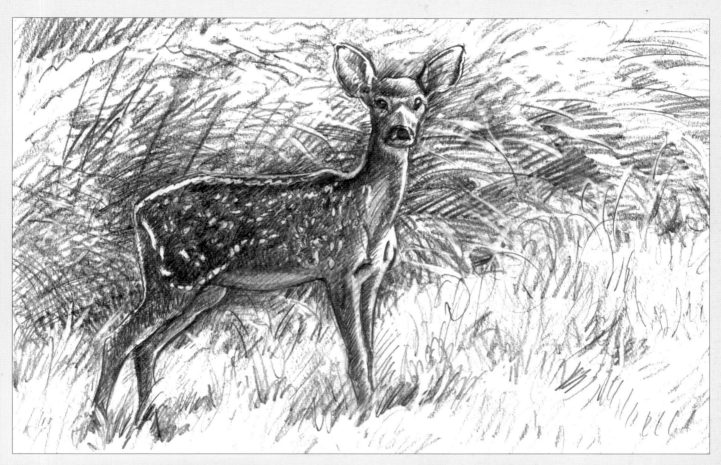

Artist 2 uses crosshatching to block in an impression of the wild vegetation. His foreground grasses are made with sketchy pencil marks.

The underbelly is gradated to achieve the round form. Note, however, that the lights are not white but a lower midtone and that the edge is rendered with a dark pencil outline, not as an extreme highlight.

DEER IN THE LIGHT

(11.8 X 16.5 IN. / 30 X 42 CM, GRAPHITE ON DRAWING PAPER)

"The subject gave me ample opportunity to express my enjoyment of the rich possibilities inherent in a range of tonal values using soft pencils. I responded sensuously to its textures and tones and translated this into the line and smudge of graphite on paper."

Peter Partington

COMPARING THE WORKS

Both pieces capture the deer's beauty. Artist 1 renders the vegetation in a flowing style that mimics the animal's soft fur, whereas Artist 2 uses heavier, directional strokes that are similar in tone to the body to suggest oneness with its environment. Powerful yet sensitive, both compositions make excellent use of dramatic backlighting.

Tree-lined riverbank

David Poxon and Martin Taylor choose graphite for their compositions of this calm, winding river. An exercise in aerial perspective, the receding row of trees guide the eye toward the thicket at the bend. Keep the darkest and most detailed elements in the foreground and the lightest and least distinct in the background for a greater sense of recession.

■ **Materials**
HB pencil
2B pencil
4B pencil
Ruler
Kneaded eraser
Blending stump
Incisor tool
Smooth drawing paper

■ **Techniques**
Perspective, pages 26–27
Composition, pages 28–29
Hatching, pages 13 and 17
Incising (impressing), page 13
Blending, page 17

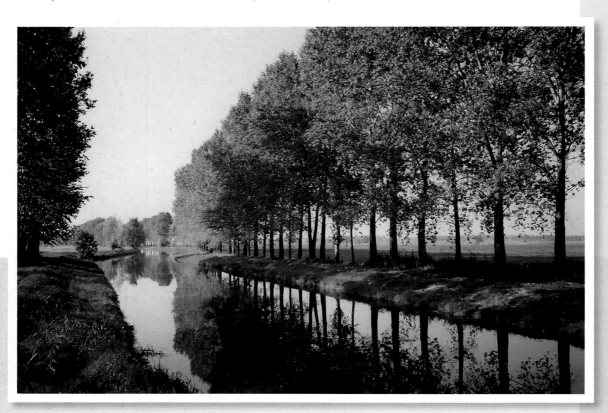

SURVEYING THE SCENE
This tranquil landscape can be modified to express a different mood, which could be anything from bright and cheerful to dark and gloomy. Conveying emotion in a drawing can be accomplished in many ways, such as by altering the light and shadows to suggest a particular time of day, enhancing or minimizing the foliage to indicate a specific season, or changing the sky and water to reflect certain weather conditions.

■ **Materials**
HB pencil
2B pencil
4B pencil
Plastic eraser
Smooth drawing paper

■ **Techniques**
Perspective, pages 26–27
Composition, pages 28–29
Stippling, page 13
Scribbles and squiggles, page 13
Lifting out highlights, page 17

ARTIST 1:
David Poxon

Starting with an HB pencil, Artist 1 uses a variety of grades to build up tone in successive layers. He blends the distant trees to contrast the rigid trunks, uses linear marks to add interest to large areas of tone, and suggests the movement of the river with a few strokes, keeping it a glassy reflection. Overall, he achieves a darker and more somber mood than Artist 2.

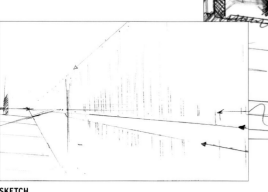

SKETCH
This sketch by Artist 1 shows the main perspective lines that will underpin his drawing. He uses a ruler and one-point perspective to channel the viewer toward the distant focal point.

1 INCISING (IMPRESSING)
Having placed his key guidelines, Artist 1 faintly outlines the tree canopies and trunks with an HB pencil. He then uses an Allen key as an incisor tool to incise sections of the paper's surface. These impressed lines will stay white even after tone is applied over them.

ARTIST 2:
Martin Taylor

Artist 2 has a very different way of working. He makes no use of blending methods (he is less interested in large, tonal masses than in texture), so builds up each area with a series of small dots, dashes, and squiggles to describe grasses, foliage, and the rippling river. He lightens the overall values to give the piece more energy and rhythm. There is a happy, bright mood to this picture.

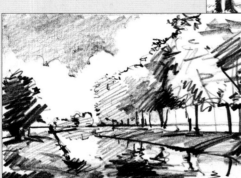

SKETCH
Artist 2's sketch shows the main tree shapes blocked in over a lower horizon line. Compositional choices are the main considerations at the preliminary sketch stage.

1 OUTLINES
Artist 2 divides his working surface into three sections, placing the horizon line at eye level near the lower third line. Using an HB pencil, he draws an outline of the tree line, water's edge, and distant bend in the river. He reduces the height of the left-hand tree.

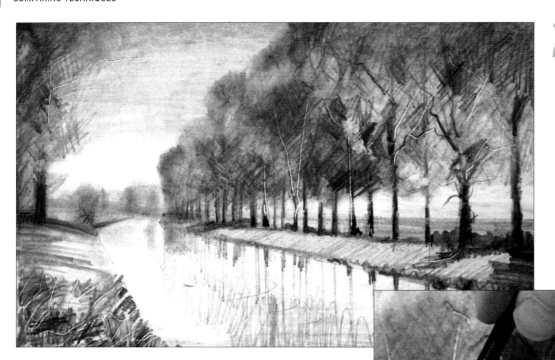

INITIAL TONES

Artist 1 uses a 2B pencil to apply the first midtones to the whole scene but excludes sections of the river that will remain white. He then blends the sky area with a stump, gradating the tones from dark at the top to light at the horizon.

This close-up view shows how Artist 1 shades across the impressed marks with a 2B pencil. Areas that have been incised will show up as white lines.

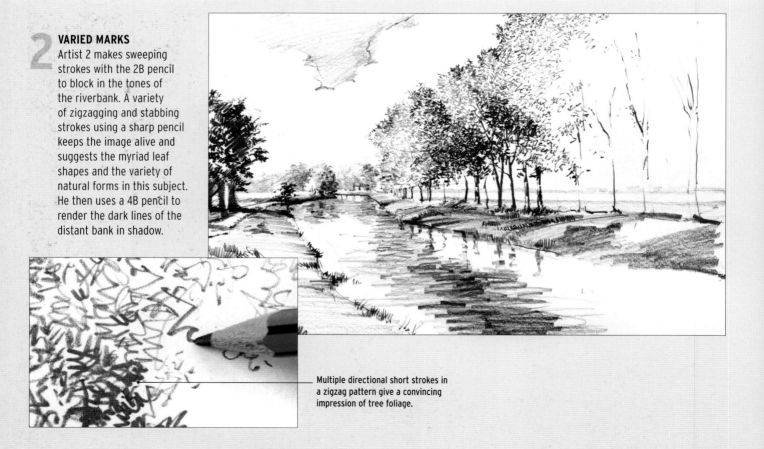

VARIED MARKS

Artist 2 makes sweeping strokes with the 2B pencil to block in the tones of the riverbank. A variety of zigzagging and stabbing strokes using a sharp pencil keeps the image alive and suggests the myriad leaf shapes and the variety of natural forms in this subject. He then uses a 4B pencil to render the dark lines of the distant bank in shadow.

Multiple directional short strokes in a zigzag pattern give a convincing impression of tree foliage.

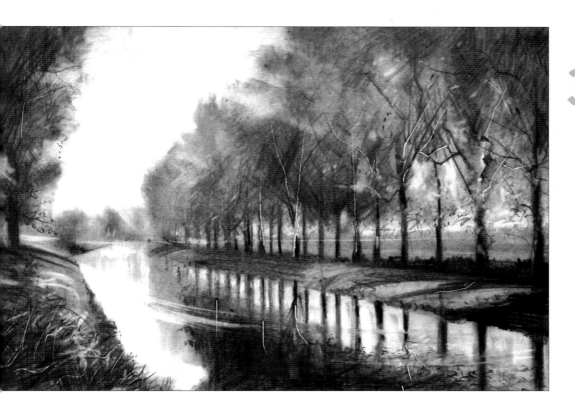

3 **MIDTONES FOR DEPTH**
Artist 1 adds further tone with a 2B pencil and starts to create depth by layering tone on the tree shapes, massing their forms into broad areas. After each application, he blends with a stump. He then defines the reflections of the trees on the river's surface. The general rule with reflections is that dark objects will appear slightly lighter as reflections, whereas light objects will appear darker.

3 **BLOCKING IN**
To create the rich darks of the foliage, Artist 2 uses heavy pressure with the 4B pencil. He enlarges the left-hand tree to balance the composition. Using horizontal strokes, he blocks in areas of water that are in the shade, leaving sections of the tree trunks white. Adding darks around these white shapes emphasizes the forms of the trunks. Foreground grasses, diminishing in size as they recede into the distance, aid the illusion of perspective.

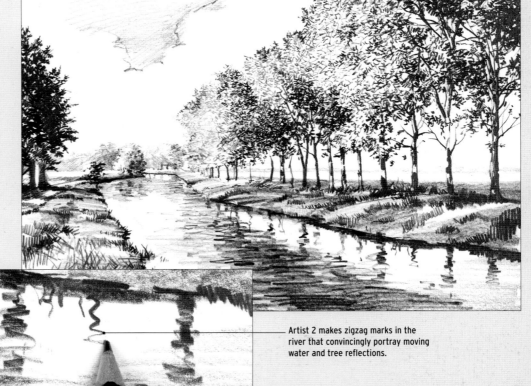

Artist 2 makes zigzag marks in the river that convincingly portray moving water and tree reflections.

FINAL STAGE

More tone is applied with 2B and 4B pencils and, with each increase in tone, the indented marks gain prominence. To emphasize the stillness of the setting, Artist 1 bleeds the trees on the left off the top of the paper, giving the viewer the sense of being enveloped in the scene. He uses a kneaded eraser to lift out highlights in the sky and to suggest gentle movement in the water.

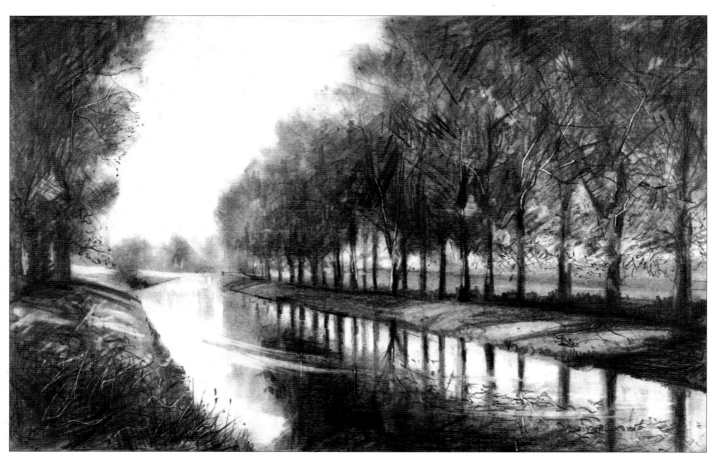

Water ripples are created by lifting out the graphite, using the kneaded eraser in a curved movement. The nearest ripple seamlessly disappears into the sky reflection.

Artist 1 blends the farthest trees into the sky area in order to emphasize the sense of space. The boundary between sky and land is lost in a subtle haze.

A QUIET PLACE

(11 X 16 IN. / 28 X 41 CM, GRAPHITE ON SMOOTH DRAWING PAPER)

"Once the main perspective lines are in place, you can relish all the elements of this quiet river scene, such as the subtle gradations of tone and peacefully warm afternoon sun, all the time admiring the view and being tempted to stroll along that riverbank. As artists, we can revisit these wonderful places as often as we like with our pencils and paper."

David Poxon

FINAL STAGE

In the last stage of development, Artist 2 reviews the whole drawing. Further tones are added, particularly in the left foreground. Then he strengthens the water reflections. Finally, he uses the hard edge of a plastic eraser to slice across the water, emphasizing its movement.

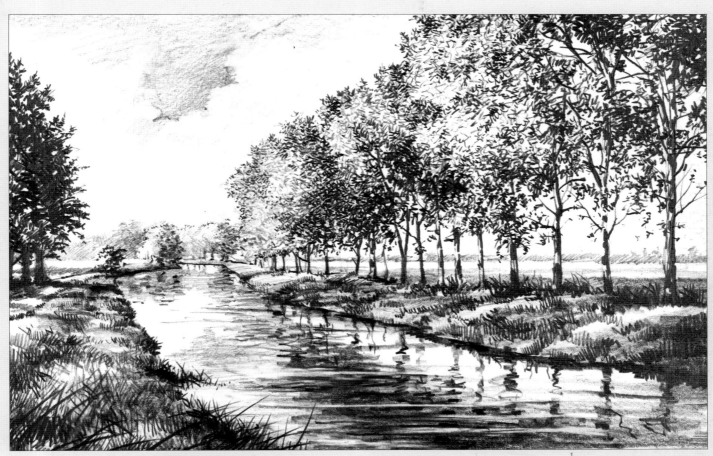

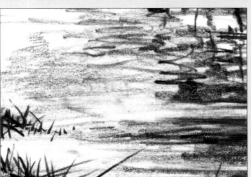

Artist 2's surface detail moves from high key to low key in zigzag patterns. The tree reflections are almost woven into the surface pattern for a convincing water effect.

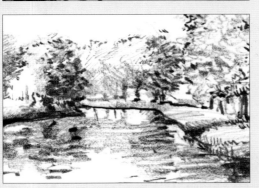

The bend of the river is emphasized with a strong angular line along the bank, thus steering the viewer into the far distance.

REFLECTIONS
(9 X 13 IN. / 23 X 33 CM, GRAPHITE ON SMOOTH DRAWING PAPER)

"Perspective is key with the riverbend as the focal point. Consider the soft tones and scale of the distant trees. Water is always tricky as it will generally reflect, and the artist is presented here with the opportunity to be free and expressive with his marks."

Martin Taylor

COMPARING THE WORKS

Both pieces produce a faithful rendition of the photograph even though the artists use two very different approaches. Artist 1 aims for a tranquil ambience by skillful blending and softening of tones. Artist 2 opts for lively movement with a variety of marks. Compositional changes and aerial perspective give both landscapes good depth.

Figures

People are compelling subjects to draw and there is a range of approaches to depict them. You can, for example, stay true to the model or reference photograph and capture a realistic likeness, or you can merely suggest features for an abstract work. Adrian Bartlett and David Poxon take different approaches to their graphite drawings.

■ **Materials**
HB pencil
2B pencil
Drawing paper

■ **Techniques**
Perspective, pages 26–27
Hatching, pages 13 and 17

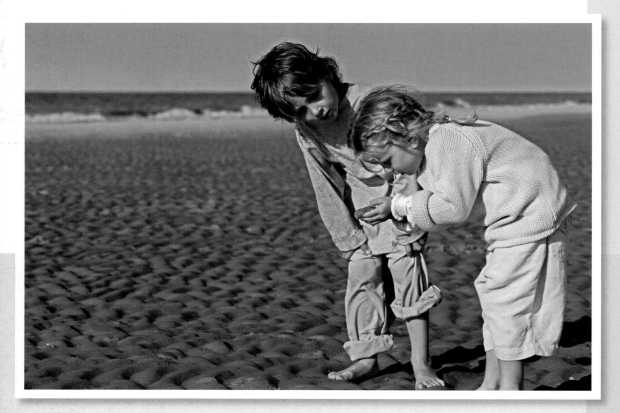

LEADING THE EYE
A good composition needs some sort of visual path for the viewer's eye to follow. This photograph doesn't include an obvious visual path, so the artists must establish one. Artists can use a number of techniques to lead the eye: incorporating diagonal and curving lines, avoiding symmetry, overlapping elements, or including areas of high contrast.

■ **Materials**
HB pencil
B pencil
2B pencil
4B pencil
Blending stump
Plastic eraser
Smooth drawing paper

■ **Techniques**
Composition, pages 28–29
Perspective, pages 26–27
Crosshatching, pages 13 and 17
Blending, page 17
Lifting out highlights, page 17

ARTIST 1:
Adrian Bartlett

Artist 1 depicts this scene with quick, sketchy lines that are left unblended for a rougher look. He leaves the figures mainly white to suggest strong lighting, which contrasts the shadows on the beach and adds drama to the scene.

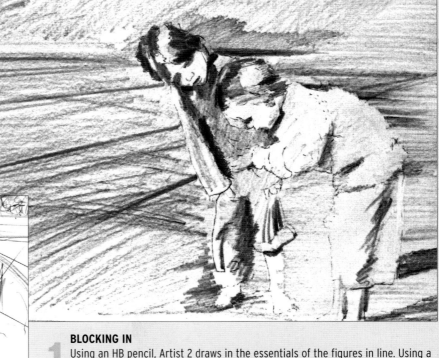

SKETCH
Artist 1's preparatory sketch reduces forms to minimal linework. Care is taken to place the figures in the correct spatial dimension by overlapping lines (the girl's outline over the boy's and the boy's outline over the horizon).

1 PLACING THE SUBJECT
The figures are placed so that the girl's hand draws in the eye of the viewer. Artist 1 uses a 2B pencil to block in the ocean in the background and an HB pencil to add some shadow areas on the children.

ARTIST 2:
David Poxon

Artist 2 takes a softer approach, building up layers of deep tone and blending to achieve the look of charcoal. He also adds more detail to the childrens' faces, hair, and clothing, staying true to the reference photograph.

SKETCH
This working sketch shows how Artist 2 practices placing the children's heads and main features using perspective lines and a simple grid measuring system.

1 BLOCKING IN
Using an HB pencil, Artist 2 draws in the essentials of the figures in line. Using a B pencil, he then blocks in most of the paper with a halftone. While doing this, he thinks ahead and decides to move the horizon line upward so he can contrast the girl's light hair against the dark ocean later in the drawing.

2 EMPHASIZING LIGHT

To give the impression of strong sunlight, Artist 1 leaves the figures mainly as white and surrounds them with dark graphite. Diagonal shading leads into the focal point.

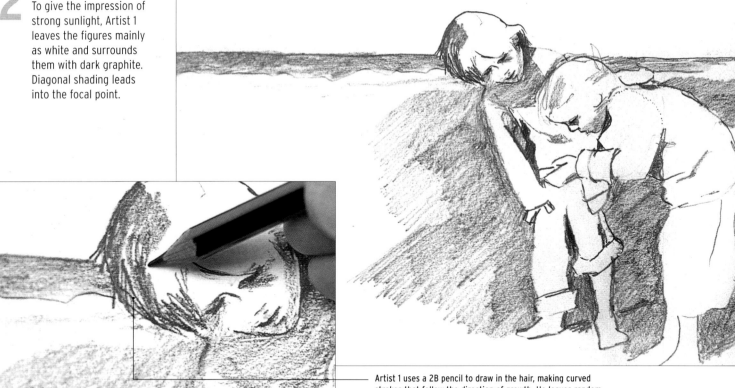

Artist 1 uses a 2B pencil to draw in the hair, making curved strokes that follow the direction of growth. He leaves random breaks in the hair shading to act as highlights.

2 AERIAL PERSPECTIVE

Artist 2 begins to blend the sky and sea with a stump. This will help give the illusion of aerial perspective by softening any distant, hard edges. When working on the beach and foreground, he blends along an imagined diagonal line. Diagonals help to lead the eye into the picture.

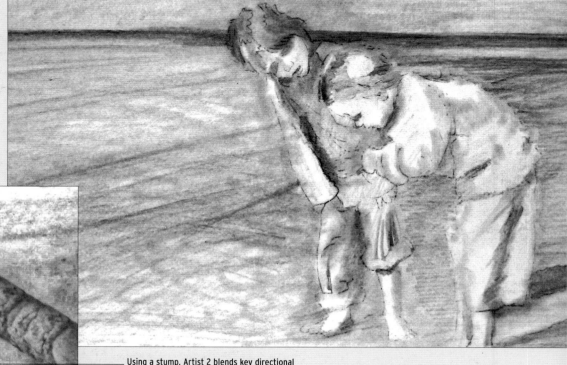

Using a stump, Artist 2 blends key directional strokes toward the distant horizon.

Using diagonal strokes in a midtone, Artist 1 sketches in the beach. The tonal difference between the white faces of the children and the shadows on their clothing folds gives emphasis by contrast.

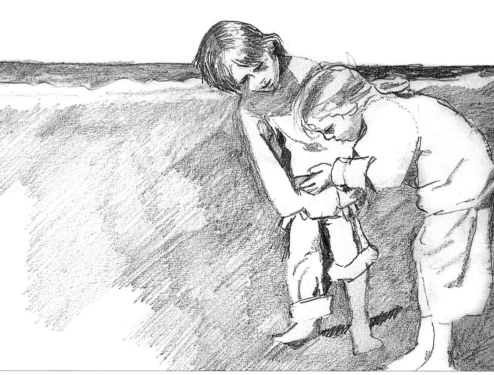

3 CONSIDERING TONE
Artist 1 decides to make the shadows on the beach and the boy's hair the darkest tones. He leaves the sky area as white paper, which contrasts with the dark ocean. He sketches in the beach and clothing folds as a midtone value.

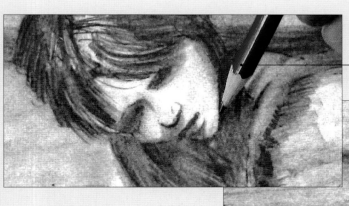

Using a 2B pencil, Artist 2 layers graphite onto the area underneath the chin. This will push the light facial features forward to help define the form and structure.

3 FORM AND LIGHT
Using a 2B pencil and alternating between crosshatching and blending techniques, Artist 2 builds tonal structure within the figure area. To recreate a three-dimensional impression on the flat picture plane, he carefully follows the patterns of light and dark around the faces and clothing, always stroking in the same direction as the flow of light.

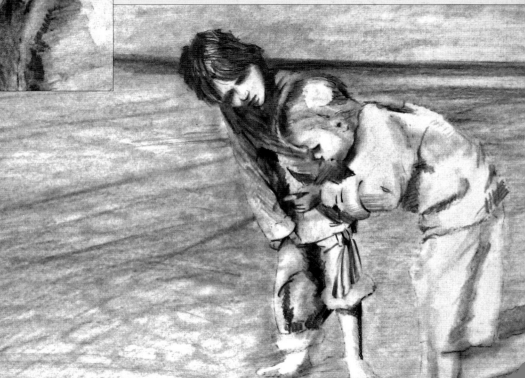

FINAL STAGE
Artist 1 completes the beach area with more midtone shading, always stroking in the same diagonal direction. Here he departs from the reference image to good effect.

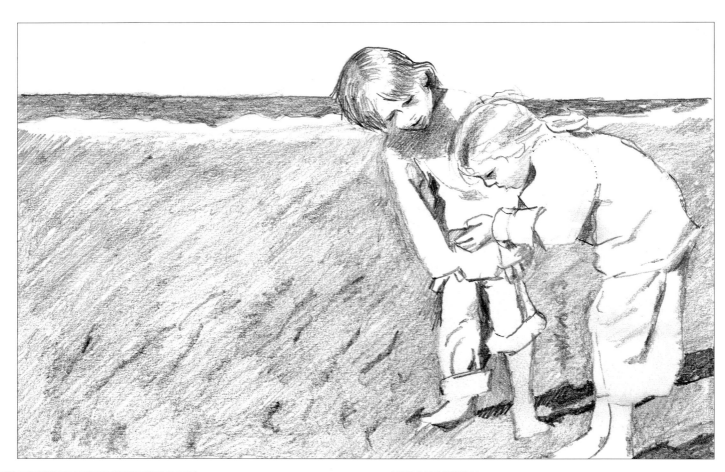

The young girl's sunlit face is entirely supported by the dark, crescent shadow between her chin and sweater. The edge of her light face, which is shown against a white sweater, has been given an outline to define the profile.

The clothing is drawn with very little work on the folds. This economical style of drawing is repeated throughout the entire drawing, with outlines added for definition where needed.

THE DISCOVERY
(7.9 X 11.8 IN. / 20 X 30 CM, GRAPHITE ON DRAWING PAPER)

"I am drawn to the intense look of concentration on the faces of the children as they peer at something the little girl is holding in her hands but which the viewer cannot identify. I also like the contrast on focus between this tiny object and the vast empty stretch of beach all around."
Adrian Bartlett

FINAL STAGE

By patiently building up the layers of graphite, Artist 2 begins to reach full tonal value. Placing the darkest darks with a 4B pencil, he alternates between hard shapes, such as those of the heads and certain areas of the clothing, and blended areas to create an exciting variety of lost and found edges. Finally, he retrieves the extreme highlights with a plastic eraser.

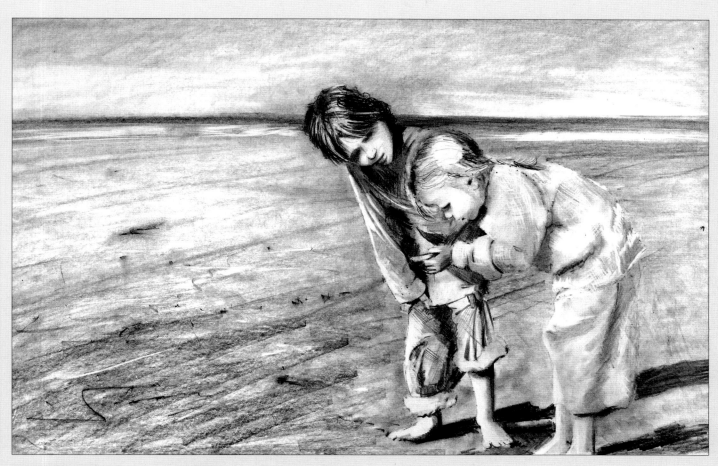

The girl's face is drawn against the dark tone of the boy's sweater. This, coupled with the shadow placement between her face and hand, draws the eye to the center of interest.

Artist 2 blends folds in the boy's clothing so the shading moves through the entire tonal scale. The folds in the girl's clothing are rendered with soft, high-key gradations, with the white of the paper providing the extreme highlights.

MAGIC TIME

(11 X 16 IN. / 28 X 41 CM, GRAPHITE ON SMOOTH DRAWING PAPER)

"Establishing the seaside situation gives supportive meaning to capturing the children's expression of total absorption. Grouping the two figures and working on the overall shapes and shadow structure is more important than overdoing any facial detail."

David Poxon

COMPARING THE WORKS

The subject is challenging as well as captivating because to achieve the impact that it deserves, it is important to draw good likenesses of the children. Artist 1 does this mainly through outline, though form is suggested by light shading. Artist 2 uses no outline, except in the first stage of the drawing, and relies on tonal gradations throughout.

Building

The old, crumbling stonework of this French farmhouse provides a great study in texture for Diane Wright and Martin Taylor, who choose to render it in graphite. When depicting rough textures such as stone, it's important to create distinct contrasts between light and dark to suggest the nooks and crannies of the uneven surface.

Materials
HB pencil
2B pencil
4B pencil
2mm clutch pencil with H, 2H, 3H, and 4H leads
3mm clutch pencil with an HB lead
5mm clutch pencil with 2B, 4B, and F leads
Plastic eraser
Kneaded eraser
Chamois
Makeup brush
Smooth drawing paper

Techniques
Holding a pencil, page 12
Crosshatching, pages 13 and 17
Blending, page 17
Scribbles and squiggles, page 13
Lifting out highlights, page 17

EMPHASIZING TEXTURE
Although this photograph provides a simple, straight-on view of the farmhouse, the tonal value of the building is somewhat dark and flat, especially in the areas of shadow, making it difficult to read the shapes and textures. To remedy this, an artist could lighten the overall tone of the building and create areas of strong contrast to bring out the shapes and textures of the building as well as the surrounding foliage.

Materials
HB pencil
2B pencil
4B pencil
T-square
Plastic eraser
Chamois
Smooth drawing paper

Techniques
Stippling, page 13
Curved hatching, page 17
Hatching, pages 13 and 17
Blending, page 17
Scribbles and squiggles, page 13
Lifting out highlights, page 17

ARTIST 1:
Diane Wright

Artist 1 uses a combination of wood-cased pencils and a mechanical clutch pencil because it holds thicker leads of varying grades (from hard to soft). She uses a variety of implements to blend and lift out the graphite. Using a detailed approach, she suggests the building's masonry and the trees' leaves with shading, highlighting, and blending.

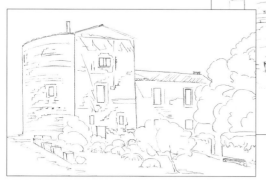

SKETCH
After experimenting with the format and making minor compositional changes, a light outline is drawn with an HB lead mounted in a clutch mechanical pencil. Note that the small building on the left side of the photograph has been left out at this stage.

1 THE SKY
With any outdoor subject, the sky establishes the atmosphere and time, affecting all other elements. Artist 1 uses the sketch grip to crosshatch three layers of graphite with the 5mm clutch pencil containing an F lead. She places the first layers horizontally and subsequent layers vertically. With the chamois wrapped around her index finger, Artist 1 applies firm, even pressure to the sky area. She then uses a plastic eraser to lift out some of the cloud shapes, sweeping away any surface debris with the makeup brush.

ARTIST 2:
Martin Taylor

Artist 2 uses a variety of pencil marks to describe the stonework and the leaves of the trees. Unlike Artist 1, he chooses not to blend the graphite. Instead, he keeps his strokes loose and bold, creating a high tonal contrast, which results in a more graphic composition.

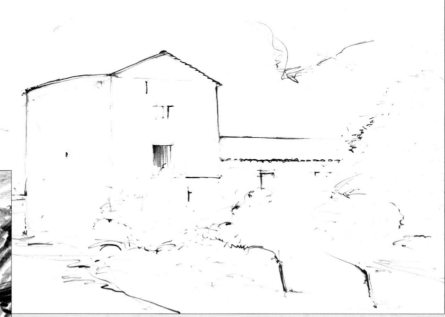

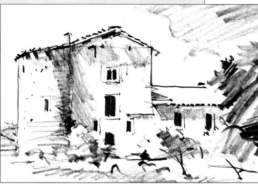

SKETCH
Artist 2 emphasizes the key darks of the window recesses in his preliminary sketch. The dark tree mass to the right will act as a foil against which the sun-drenched walls will be contrasted.

1 THE DRAWING
When drawing buildings, it is important to create straight vertical lines. Artist 2 uses the T-square and an HB pencil to define the building outlines and position the apex of the roof and the side walls before placing the other elements. He lowers the height of the buildings to allow for more sky and cloud shapes and removes the left-hand building.

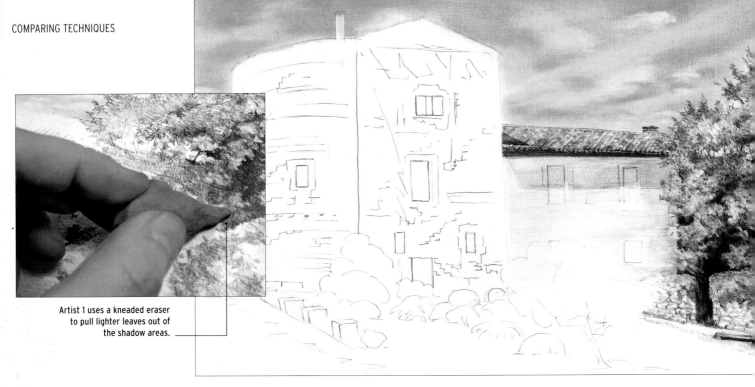

Artist 1 uses a kneaded eraser to pull lighter leaves out of the shadow areas.

2 TREES AND TILES

Artist 1 is left-handed and works from right to left. With a combination of loose and random markings, she blocks in the general tree shape and leaf bundles. This is the first of many such layers applied to this area. Each additional application builds tonal depth and texture. The vines on the stone wall are drawn in with smaller, tighter scribbles. The tiled roof is carefully aligned, details are dropped in, and a small stone bench and path are drawn to lead the viewer's eye to the building.

2 DRAWING FORM

Starting with the left-hand building and a 2B pencil, Artist 2 starts to describe the curving tower in sweeping, directional strokes. A series of dot-and-dash marks illustrate the textured brick and stone and a strong shadow angled downward further helps to define the cylindrical form.

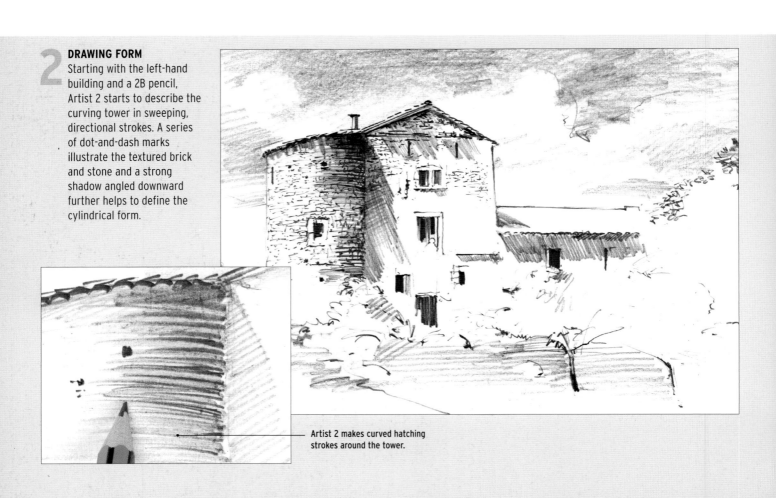

Artist 2 makes curved hatching strokes around the tower.

3 THE FARMHOUSE
Artist 1 uses the 2mm clutch pencil with leads from 2H to 4H to describe the main left-hand building. She uses a kneaded eraser to lift out highlights after each section is drawn. The window openings offer hints of the interior, and she pays attention to the cast shadows that help to describe the tower's cylindrical form. She is careful to draw stone crevices through the shadows and highlight areas.

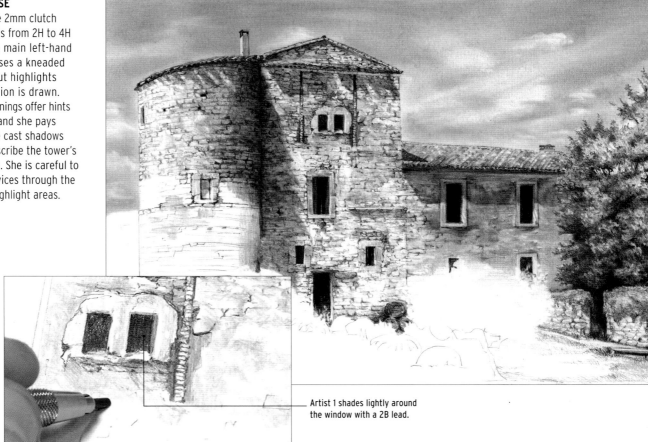

Artist 1 shades lightly around the window with a 2B lead.

Artist 2 lifts out cloud shapes with a plastic eraser and softens some of the edges.

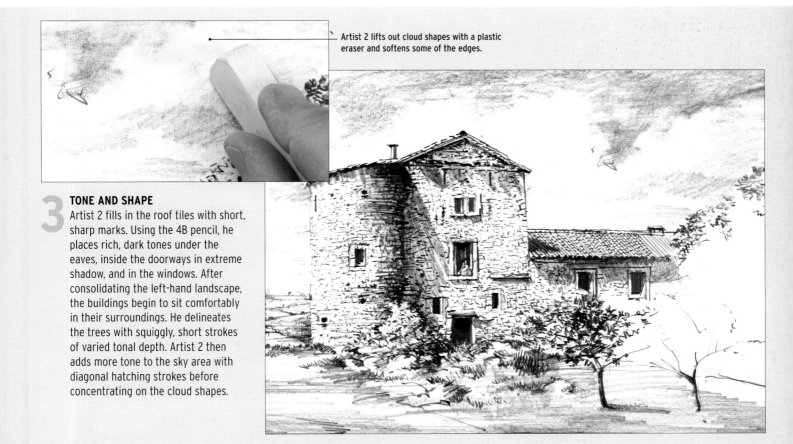

3 TONE AND SHAPE
Artist 2 fills in the roof tiles with short, sharp marks. Using the 4B pencil, he places rich, dark tones under the eaves, inside the doorways in extreme shadow, and in the windows. After consolidating the left-hand landscape, the buildings begin to sit comfortably in their surroundings. He delineates the trees with squiggly, short strokes of varied tonal depth. Artist 2 then adds more tone to the sky area with diagonal hatching strokes before concentrating on the cloud shapes.

FINAL STAGE

Using directional strokes that lean into the scene, Artist 1 strokes in the foreground grasses with 2H and F leads. The stone blocks on the edge of the road and path add depth and direction for the viewer. She defines the larger foreground rock more clearly and positions three small trees to steer the viewer into the scene. Finally, she darkens the shadows on the building and some of the stonework in the lower sections with the 4B pencil to pull the overall tonal range together.

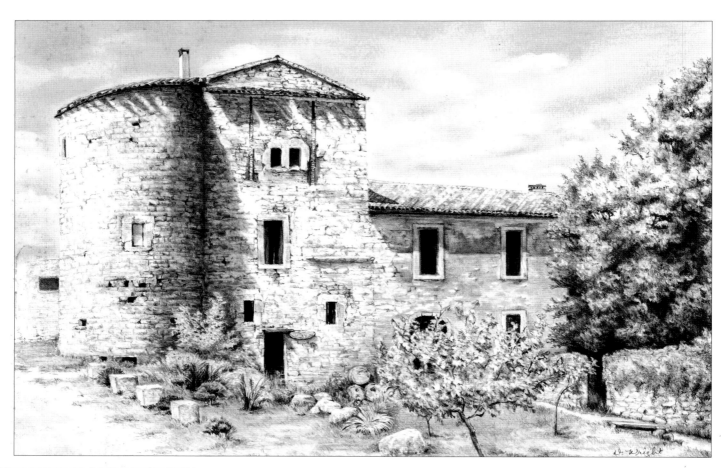

Artist 1 renders the shadows on the wall lightly enough for the texture underneath to remain visible. Shadow shapes with soft gradated edges give a heightened atmosphere.

Multiple abstract markings in the foliage give the impression of very detailed rendering. Carefully recording the interplay of light against dark leaf masses with correct tonal placement conveys the tree canopy with conviction.

FERME AUBERGE

(9.5 X 14 IN. / 24 X 36 CM, GRAPHITE ON SMOOTH DRAWING PAPER)

"The textured masonry, tiled roof, and shadows dancing across the stonework give this old French farmhouse character. The viewer's eye is led gently around the scene by the supporting elements: the clouds, the gated stone wall, and the lean of the trees. The representational approach conveys the impression of the object without having to draw every stone or leaf."

Diane Wright

FINAL STAGE

Concentrating on the texture of the building surfaces, Artist 2 lays a variety of marks over those already drawn, sharpening the tonal contrasts. Soft shading in the foreground, tree trunks, leaf masses, and shadows unifies the scene. Artist 2 finishes by adding a human element; if you look closely, you can just make out the slight shape of a figure in one of the windows.

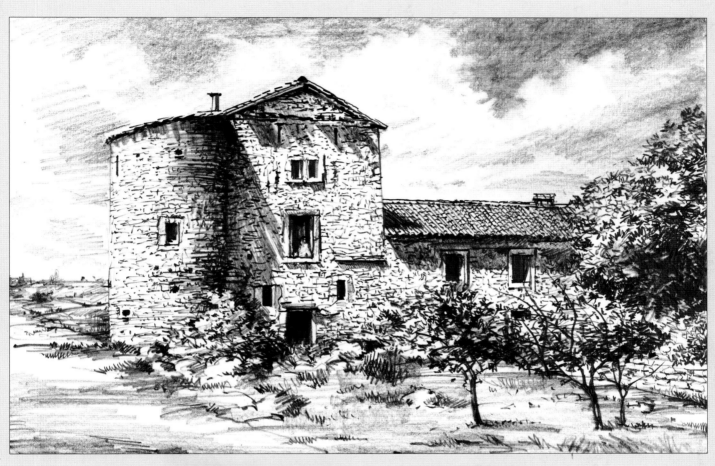

The roofline contour is created by placing diagonal cast shadow shapes. Artist 2 has interpreted detail not visible in the reference image and thereby concentrated attention on the deep shadow area of the cylindrical tower.

Wispy branches have been angled to direct attention back into the picture, steering the eye to the large window shape on the lower building.

FRENCH FARMHOUSE
(8 X 11 IN. / 20 X 28 CM, GRAPHITE ON SMOOTH DRAWING PAPER)

"This scene is a wonderful opportunity for rendering different kinds of texture. Different marks are used for the stonework and roof tiles. The curve of the sunlit tower casts a strong shadow and adds character. Soft shading and tiny squiggles render the trees."
Martin Taylor

COMPARING THE WORKS

The important differences between the drawings are compositional and tonal. Artist 1 has made more of the wall behind the trees on the right and the line of stones on the left to lead the eye into the picture, whereas Artist 2 has omitted the small building on the left and given the sky more importance. The tonal contrasts are stronger also in this image, creating the impression of bright sunlight.

Birds

This row of parakeets perched on a branch creates a simple, cheerful scene, with a bird on each end framing the line-up. The subtle diagonal of the branch and the variations in the birds' poses provide just enough interest to break up the symmetry and create an interesting composition. Both artists recreate this scene in graphite.

■ **Materials**
B pencil
2B pencil
4B pencil
Plastic eraser
Smooth drawing paper

■ **Techniques**
Holding a pencil, page 12
Hatching, pages 13 and 17
Crosshatching, pages 13 and 17
Lifting out highlights, page 17

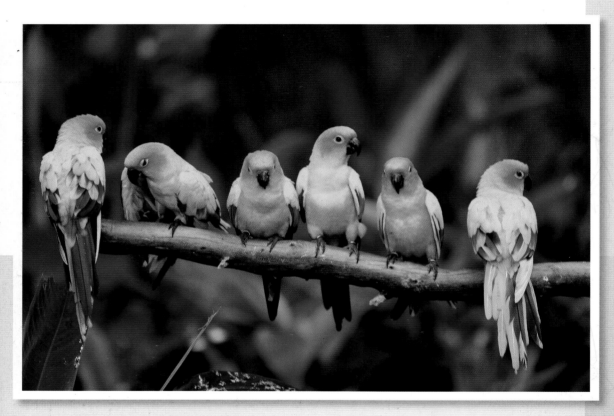

DECIDING ON A BACKGROUND

With a reference like this, artists must choose whether to accentuate the simplicity of the composition or complement it by adding interest. In the photograph, the distant foliage provides a dark, cool background with vague shapes that echo the tails of the birds. The artists can use this contrast to play up the pattern for an energetic feel. Alternatively, they can minimize or leave out the background completely, addressing the birds and branch alone for a clean, focused look.

■ **Materials**
2mm clutch pencil with a 2B lead
4B pencil
Medium graphite stick
Plastic eraser
Cold-pressed drawing paper

■ **Techniques**
Hatching, pages 13 and 17
Crosshatching, pages 13 and 17
Blending, page 17
Lifting out highlights, page 17

ARTIST 1:
Peter Partington

Artist 1 sees the subject as an exercise in tonal contrast, with light shapes against dark, and midtones against both lights and darks. His method is to work up from the basic positioning of shapes to a detailed drawing.

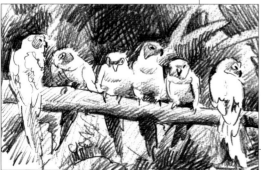

SKETCH
Preliminary sketches are a vital learning exercise. By "touring" the subject, Artist 1 explores the challenges that lie ahead, particularly the shapes of the tonal areas.

1 CONSTRUCTION LINES
After placing the branch, Artist 1 constructs the rough outlines of the birds with a 2B pencil. These construction lines can be blended into the final drawing. He also is concerned with correctly defining the body shapes and their relationships to one another.

ARTIST 2:
Philip Snow

Attracted by the decorative pattern element in the subject and more concerned with this than with the birds' environment, Artist 2 emphasizes simplicity by removing the background. He is interested, however, in their individual postures and "expressions," and he intends his drawing to be a group portrait rather than just a study of a particular species.

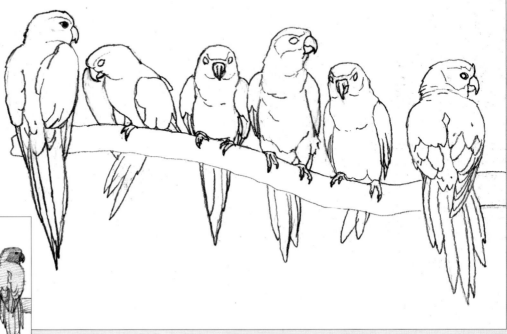

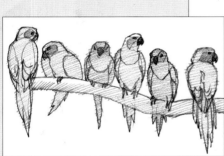

SKETCH
The focus of Artist 2's sketch is on the individual shapes of the birds and their correct proportions rather than on any tonal contrast or detail.

1 THE OUTLINE
Artist 2 takes great care to accurately draw the birds in their individual poses while still showing group unity, firmly placing them on the branch in line form with a 4B pencil.

Artist 1 draws the birds' eyes and hatches the surrounding feathers, linking the subject with the hatched background.

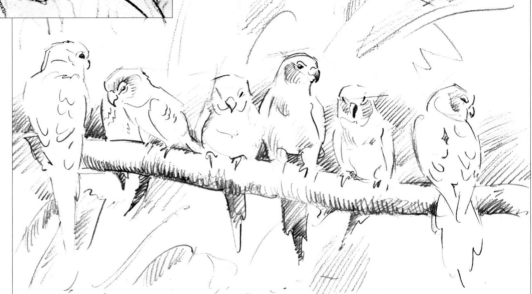

2 TIME TO CHECK

Artist 1 pauses and checks for accuracy. Once he has made minor adjustments to his outline shapes, he begins hatching in the background. With both B and 2B pencils, he adds tone to the feathers and the feathers around the eyes and links tails to bodies.

2 HATCHING

Artist 2 decides that the light source is coming from the upper left. He will pull out the lightest lights later on but for now hatches over all the bodies at a 45-degree angle with the 2B clutch pencil, leaving only the top edges clear. He then crosshatches some of the darker areas on the birds, such as their faces, and applies darker hatching to some feathers and facial features.

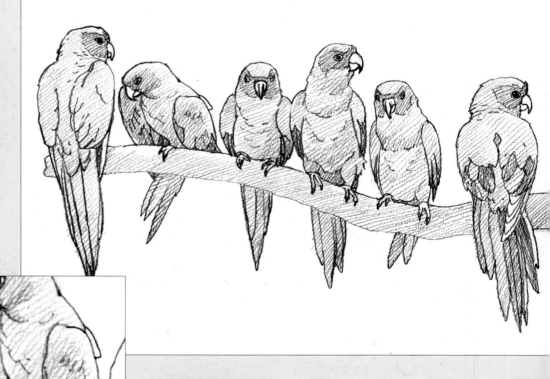

Artist 2 leaves the beak as white paper and builds up the tones on the body.

3 **MODELING THE FORM**
Artist 1 works vigorously into the background with hatching and crosshatching to suggest foliage. He takes care as he begins to model the heads while preserving the lightest tones of the bodies. By following the paths of light when adding tone, he is able to overcome foreshortening problems where heads or bodies are turned or angled differently.

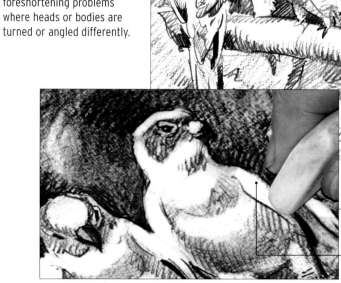

Artist 1 uses a plastic eraser to lift out highlights on the birds' plumage.

Artist 2 uses directional crosshatching strokes with the graphite stick to suggest the form of the tree branch. Note how the lines follow the curve of the bough.

3 **CROSSHATCHING**
Still using the 2B clutch pencil, Artist 2 crosshatches in the main dark areas and on the underside of the tree branch, always maintaining and preserving the highlights from the upper-left light source. He adds the birds' dark bills and eyes with the graphite stick. To convey the impression of hard, curved bills, he leaves thin slivers of light on their upper edges to contrast with the precisely placed, heavy darks.

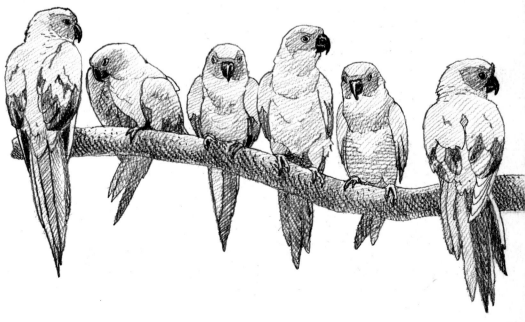

FINAL STAGE
Artist 1 builds up strong, dark depths in the background by adding soft graphite with the 4B pencil. This pushes the lightest birds forward. Crosshatching and contour shading further convey the subtle forms of the birds' bodies. Finally, he uses the writing grip to add precise details to the eyes and bills.

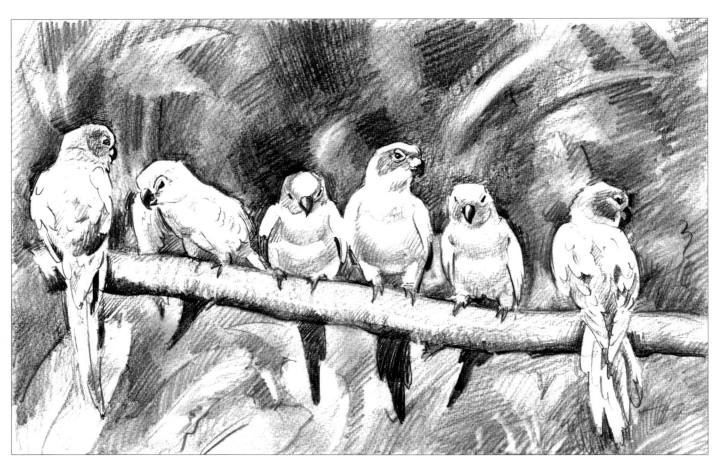

Artist 1 makes this bird his main character, evident from its demeanor as group leader. Attention is drawn specifically to the highlight on the head contrasted against the dark background.

The background foliage is drawn with abstract shapes using three tones of graphite, against which feather masses are contrasted. This adds variety and dynamism.

JUST PARAKEETS
(11.8 X 16.5 IN. / 30 X 42 CM, GRAPHITE ON SMOOTH DRAWING PAPER)

"This delightfully happy subject presents a number of repetitive shapes strung out along their perch, giving unity to the compositional arrangement. The challenge here is a search for brightness and edge contrast, which preserves the subtle tones modeling the contours of the birds. A wide range of light soft pencil, where tonal depths become richer for the background, may be appreciated within these forms."

Peter Partington

FINAL STAGE

Using both 2B and 4B leads, Artist 2 strengthens the darks with more hatching strokes. He then blends the darker strokes, especially on the right-hand side of the birds, by smudging the graphite with his finger. To emphasize the light and shade, he adds finishing stabs of dark and retrieves and lifts out further lights with a plastic eraser to strengthen the forms.

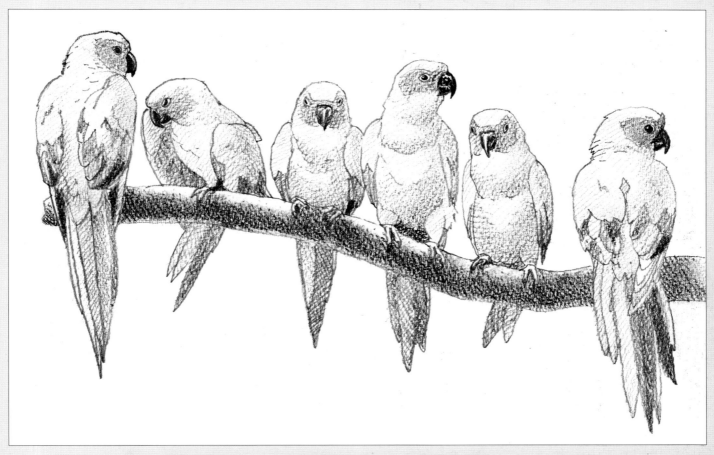

Each bird is rendered with an almost uniform system of hatching and crosshatching strokes. The clever build-up of these markings gives a feeling of the birds as a group rather than emphasizing any one individual.

Artist 2 makes the entire background a high-key shade with each bird having an outline. By doing so, he ensures that all the emphasis is on the birds.

PARROTS

(7.1 X 11.4 IN. / 18 X 29 CM, GRAPHITE ON COLD-PRESSED DRAWING PAPER)

"Scintillating colors, elegant forms, and a mischievious mien make the parrot family a most marvelous subject to draw in black and white. I relied on linework and crosshatching, assisted by shadows smudged in with my fingertips, to delineate their form and tone."

Philip Snow

COMPARING THE WORKS

The two interpretations are very different, yet each successfully captures the essence of the subject. Artist 1 has left the original composition unchanged but dramatically altered the tonal structure, whereas Artist 2 has treated the birds and branch basically as dark shapes against light. He has also moved the branch so that it almost cuts across the middle of the picture plane.

Harbor scene

Harbor scenes are unique in that they pair the bustling essence of coastal town life with the tranquility of the ocean. In this reference, the boats act as a link between the two—both conceptually and visually. Artists Ian Last and Ron Law use graphite pencil to render the relationships among the land, boats, and water.

■ **Materials**
H pencil
B pencil
2B pencil
6B pencil
Kneaded eraser
Ruler
Smooth drawing paper

■ **Techniques**
Stippling, page 13
Hatching, pages 13 and 17
Lifting out highlights, page 17

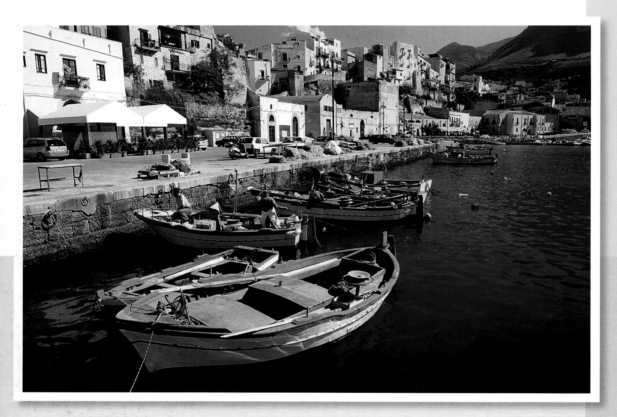

■ **Materials**
2B pencil
4B pencil
Kneaded eraser
Drawing paper

■ **Techniques**
Perspective, pages 26–27
Hatching, pages 13 and 17
Lifting out highlights, page 17

EDITING THE PHOTOGRAPH
The composition of this scene isn't perfect. In addition to eliminating some of the "clutter," the artists will have to make adjustments to even out the visual weight. There is a clear division between the lower-right area of dark, solid tone and the lighter, more intricate row of buildings in the upper-left area. The artists can diminish this sense of imbalance by changing the placement of elements or by modifying the distribution of tone across the scene.

ARTIST 1:
Ian Last

Artist 1 exploits pattern in his drawing and sees the buildings as a "backcloth" against which to deploy the strong boat shapes and ripples in the water (not visible in the photograph). He spices up the foreground with a flow of ripples and lightens the water to balance the composition. His realistic drawing style is hard-edged, with strong, clear lines, and powerful tonal contrasts.

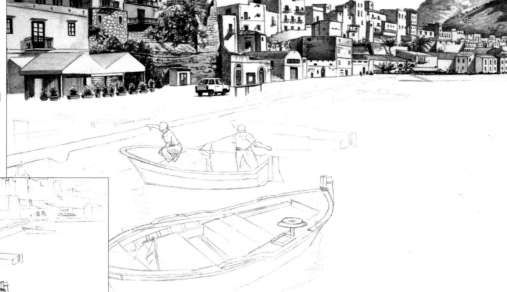

SKETCH
Artist 1 divides his picture plane with the diagonal harbor wall. The busy town section equates to roughly a third of the paper surface; the simplified water area is his main focus.

1 CONSTRUCTING THE DRAWING

Deciding that the harbor is too busy, Artist 1 removes two boats and almost all the vehicles on the quay. He uses a ruler to ensure that the harbor wall is straight, and then he renders the key lines of the wall and building with an H pencil. Once confident about the background elements, he draws light outlines of the boats with a B pencil and then returns to the buildings to add more detail, this time with the 2B pencil.

ARTIST 2:
Ron Law

Less interested in pattern than in tonal structure and atmosphere, Artist 2 interprets the buildings as one main, pale shape to contrast with the dark hill and the deep tones of the boats and water. He sees simplification as key and omits anything that does not help the composition. He moves the boats to the right to eliminate the empty space in the ocean and enlarges the mountains for balance. His sketchy, vertical rhythm of strokes offsets the strong horizontals of the scene.

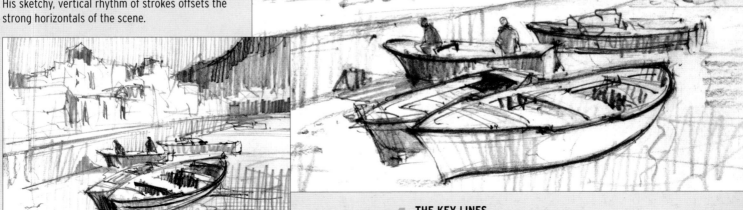

SKETCH
This drawing explores the tonal structure and placing of the main elements.

1 THE KEY LINES

Artist 2 marks the horizon line, which is at eye level. This enables him to place the key perspective lines of the harbor wall, buildings, and boats with a 2B pencil.

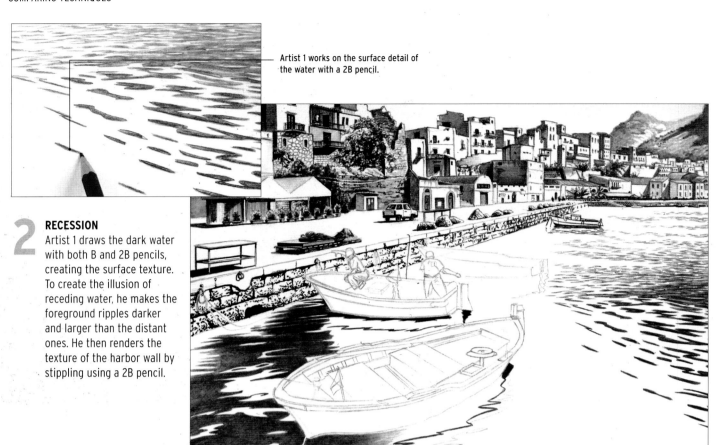

Artist 1 works on the surface detail of
the water with a 2B pencil.

2 RECESSION

Artist 1 draws the dark water
with both B and 2B pencils,
creating the surface texture.
To create the illusion of
receding water, he makes the
foreground ripples darker
and larger than the distant
ones. He then renders the
texture of the harbor wall by
stippling using a 2B pencil.

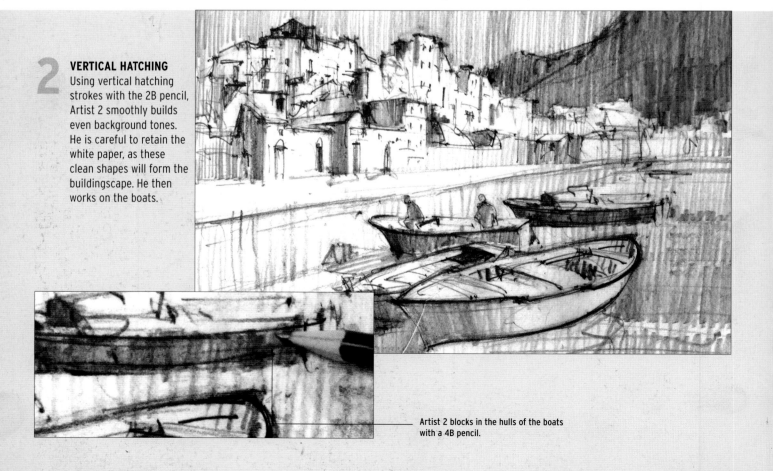

2 VERTICAL HATCHING

Using vertical hatching
strokes with the 2B pencil,
Artist 2 smoothly builds
even background tones.
He is careful to retain the
white paper, as these
clean shapes will form the
buildingscape. He then
works on the boats.

Artist 2 blocks in the hulls of the boats
with a 4B pencil.

3 BUILDING UP TONES

Artist 1 adds tonal gradations by drawing multiple parallel lines (hatching) to fill in areas. He uses an H pencil to create a pale gray or silvery tone and then a B pencil for the darker areas. By paying particular attention to the boat reflections, he is able to further render the water's surface.

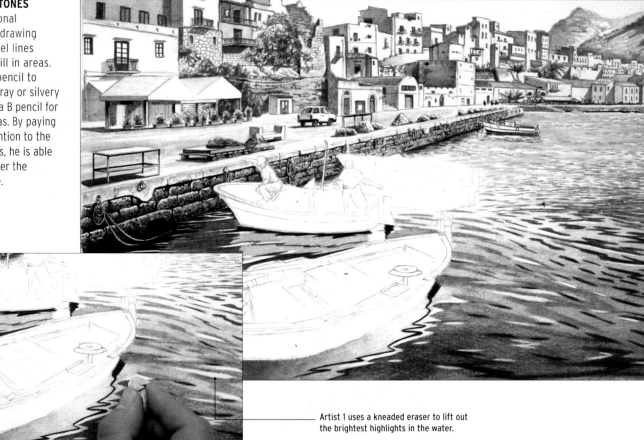

Artist 1 uses a kneaded eraser to lift out the brightest highlights in the water.

3 DISTANT MOUNTAINS

With a 4B pencil, Artist 2 hatches in the mountains. Silhouetting the sunlit harbor against the dark mountains adds an element of drama to the work. Once this low-key area is in place, he has a final reference tone from which to gauge the relative values of the jumble of boats, which form the center of interest.

Artist 2 adds the gunwale of the foreground boat.

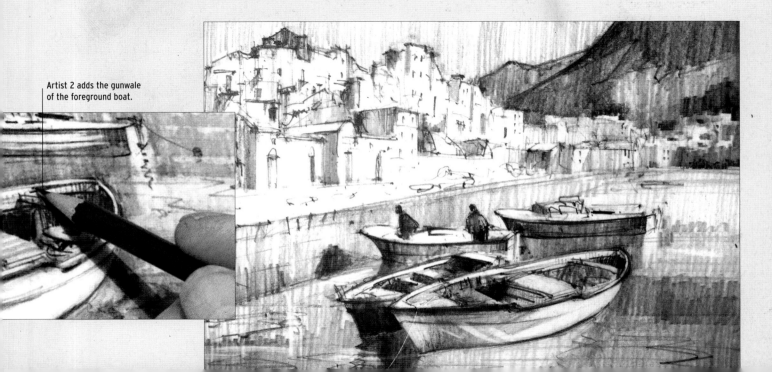

FINAL STAGE

Artist 1 finishes by working in detail on the boats. To exaggerate the tonal contrast, he uses the rich darks of a 6B pencil for the foreground boat shadows. He then brings it all together by making one final pass with the kneaded eraser to lift out the lightest areas of the scene.

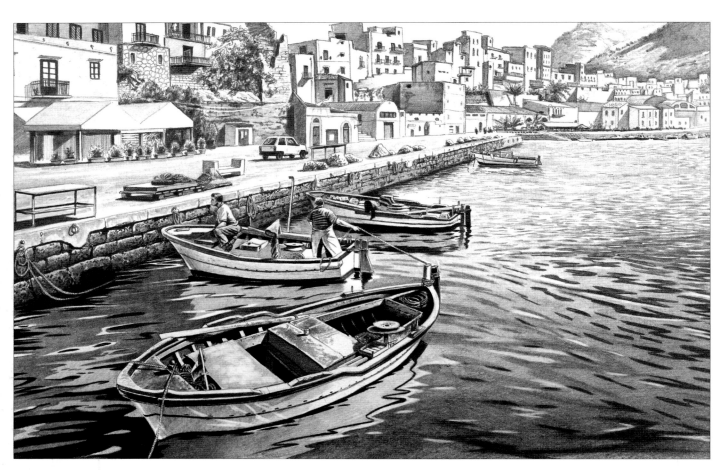

Dark tones merge into midtones, and a few well-placed lights create a convincing illusion of smooth water.

BRINGING IN THE CATCH

(10.2 X 16.1 IN. / 26 X 41 CM, GRAPHITE ON SMOOTH DRAWING PAPER)

"A full and complicated drawing with a sense of serenity about the harbor. It is satisfying to contrast the rigid structure of the buildings in the background and the small details of the boats with the fluid shapes and reflections of the water in the foreground. Adding people to the drawing gives the scene a feeling of life."

Ian Last

Artist 1 describes the waterfront buildings with few changes from the reference image, though the shadows are lightened to push the area back in space.

FINAL STAGE
Further work with the 4B pencil adds darker tones to the scene. Artist 2 then uses a kneaded eraser to render reflections in the water and to place highlights on the fishing boats.

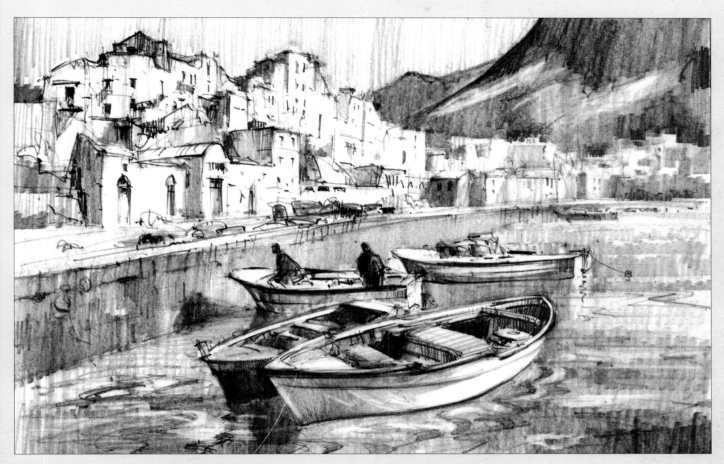

Artist 2 draws the swirling current with midtones, so it doesn't detract from the second boat's dark hull, which is the gateway into the composition.

The harborside buildings have been changed considerably. The central cluster of houses has been shifted along the quay, and the original buildings have been removed.

AT THE HARBOR
(7.8 X 12 IN. / 20 X 30 CM, GRAPHITE ON DRAWING PAPER)

"A wonderfully atmospheric scene: old buildings, sunshine, mountains, and a boat returning after a morning's fishing. Simplification is key. More detail can be used for the boats and buildings that are closer. Imagination fills in the rest."
Ron Law

COMPARING THE WORKS
Although both drawings give an accurate impression of the scene, Artist 1 has chosen to convey the life and bustle of the harbor, treating the two figures in the boat in detail, whereas Artist 2 has created a more tranquil rendering. Notice that the figures in Artist 2's drawing have been treated simply as dark shapes so they do not attract too much attention.

Portrait

Portrait artists often minimize the background to give prominence to the subject. When drawing from life, artists have control over the environment and can experiment with lighting and backgrounds. David Poxon and John Glover remove the model from her surroundings to create two dynamic portraits in graphite.

■ **Materials**
HB pencil
2B pencil
4B pencil
Blending stump
Angle finder
Smooth drawing paper

■ **Techniques**
Finding angles, page 26
Holding a pencil, page 12
Hatching, pages 13 and 17
Blending, page 17

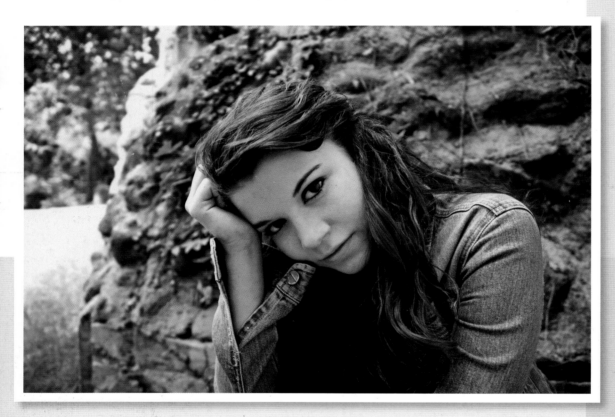

COMPLEMENTING YOUR MODEL
Even without a busy background to distract the viewer from the model, the artist still needs to establish a focal point. For this, it's always a good idea to find your subject's most flattering asset and emphasize it in the drawing. In this reference, the model's dark, expressive eyes are locked on the viewer, making them an obvious point of focus.

■ **Materials**
H pencil
HB pencil
2B pencil
4B pencil
5B pencil
Kneaded eraser
Cotton swabs
Facial tissues
Smooth drawing paper

■ **Techniques**
Hatching, pages 13 and 17
Crosshatching, pages 13 and 17
Blending, page 17
Lifting out highlights, page 17

ARTIST 1:
David Poxon

Artist 1 nearly always begins his drawings with an outline and does not begin to build up tones until he is sure that the initial drawing is accurate. If any mistakes occur, it is much easier to erase lines than it is to remove large areas of tone in later stages. For this portrait, he chooses an off-center composition and a scratchy background which contrasts the smooth skin of the subject's face.

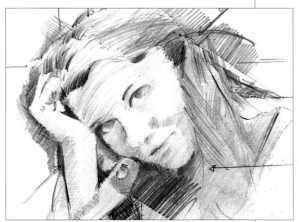

SKETCH
Artist 1 uses a preliminary study to determine the main landmarks in the woman's features that will best achieve an accurate likeness.

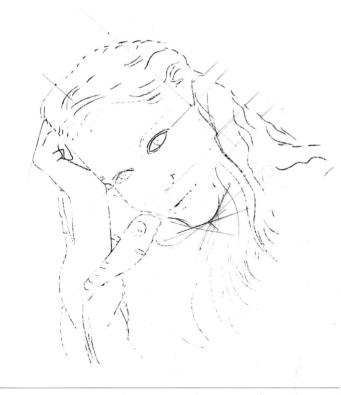

1 ANGLES AND PROPORTIONS
In his preliminary study, Artist 1 uses an angle finder to plot the exact tilt of the subject's head and the positions of the main facial features. He then carefully copies his guidelines on the drawing paper.

ARTIST 2:
John Glover

Artist 2 adopts a more sketchy approach at the start of a drawing, bringing in areas of tone from the start to establish the main areas of light and dark. Using less contrast than Artist 1, he creates a smooth flow of strokes, echoing the direction and curves of the subject's hair.

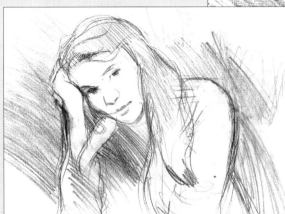

SKETCH
A quick tonal study helps Artist 2 decide where he should concentrate his key values for maximum impact.

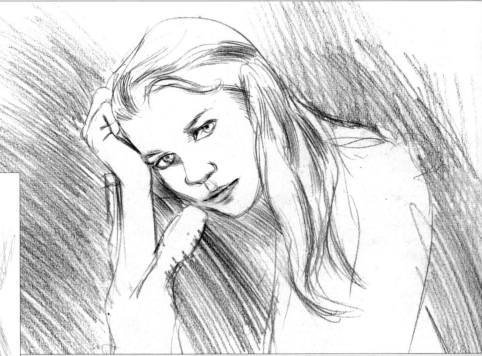

1 FACIAL FEATURES
As he draws, Artist 2 continually checks the relationship between facial features, and then begins to render them in more detail with H, HB, and 2B pencils.

2 FIRST TONES

Artist 1 draws the basic outline of the subject and begins to hatch diagonally with an HB pencil to build up initial tone. He then crosshatches across the areas of darkest tone to increase depth.

Using the sketch grip, Artist 1 hatches in the first light tonal marks.

2 ADDING TONE

Using loose hatching lines, Artist 2 begins to add more tone, indicating the light and shadow on the face. He renders the rhythmic flow of the hair with 4B and 5B pencils, softening and blending the tones with cotton swabs and facial tissues.

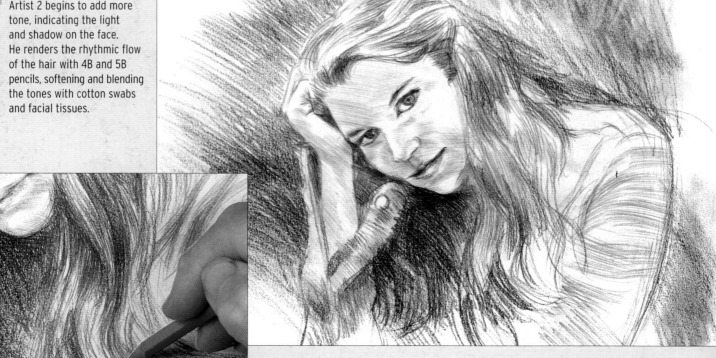

Artist 2 adds darks with 4B and 5B pencils, using strokes that follow the direction of the hair.

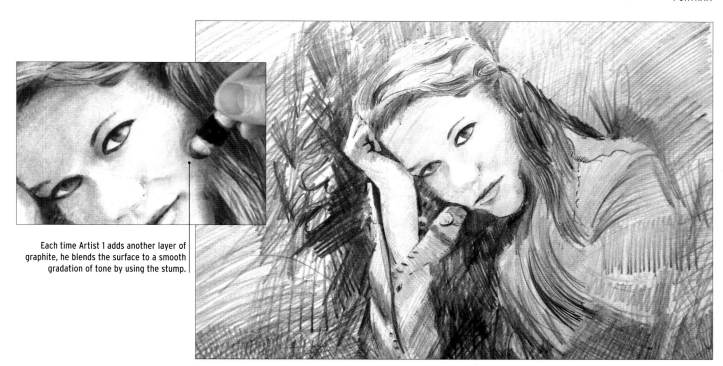

Each time Artist 1 adds another layer of graphite, he blends the surface to a smooth gradation of tone by using the stump.

3 BLOCKING IN

Now feeling confident about the likeness and the forms, Artist 1 blocks in more tones on top of the previous areas, adding layers of rich darks with a 2B pencil. He works toward final tonal value in some areas with a 4B pencil and then begins to blend with the stump.

3 MERGING THE BACKGROUND

Artist 2 decides to keep the background simple but uses a variety of strokes to give it life and interest. He merges the subject into the background by blending away some of the edges, and he lays in dark, directional lines alongside retrieved highlights on the denim jacket.

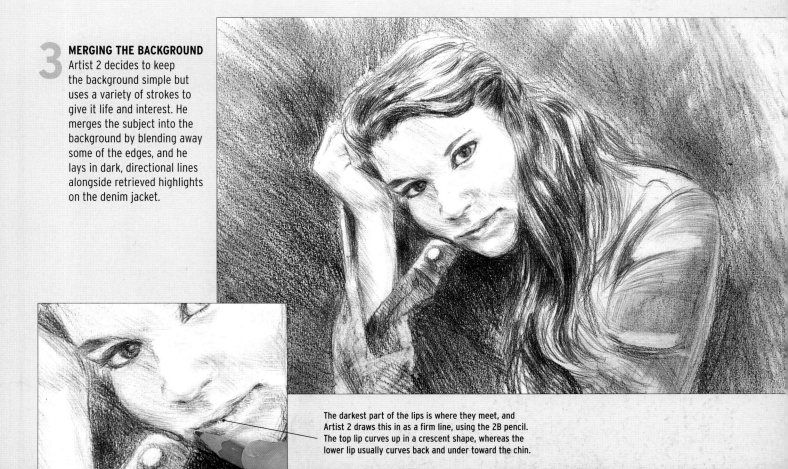

The darkest part of the lips is where they meet, and Artist 2 draws this in as a firm line, using the 2B pencil. The top lip curves up in a crescent shape, whereas the lower lip usually curves back and under toward the chin.

FINAL STAGE

To contrast with the subject's smooth complexion, Artist 1 suggests the coarse texture of the jacket with multidirectional strokes. He blends some edges and areas of the hair but leaves others hard. Finally, he completes the background, which gives the impression of a wall with light trees glimpsed beyond it.

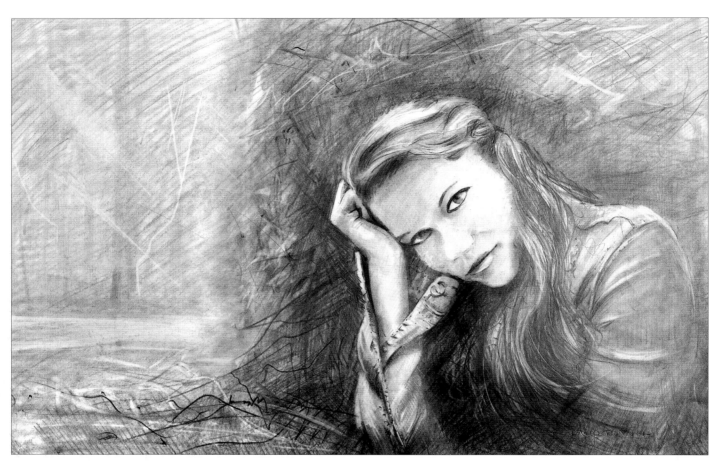

The dark area under the chin is an important structural area that provides support for the tonal variety in the facial features.

Artist 1 makes the subject's left eye a dominant facial feature. When drawing portraits, always look for the more significant eye and render it with slightly more detail.

A GIRL LIKE YOU

(11 X 20 IN. / 28 X 40.6 CM, GRAPHITE ON SMOOTH DRAWING PAPER)

"The background theme to this piece is irrelevant as the girl's eyes and expression are totally captivating. Special attention is paid to achieving an accurate likeness and the almost hidden smile is challenging. Careful layering and blending build form into the areas of the face without losing the softness; the relaxed and dreamy quality is contrasted with some robust textural work in the denim jacket."

David Poxon

FINAL STAGE

Content that he has achieved full tonal value, Artist 2 concentrates on the finer details. He works on the jacket, blending in layers of graphite with facial tissues and his fingers. A suggestion of areas of form and detail in the facial area aids the impression of a relaxed expression. Final highlights are lifted out with the kneaded eraser.

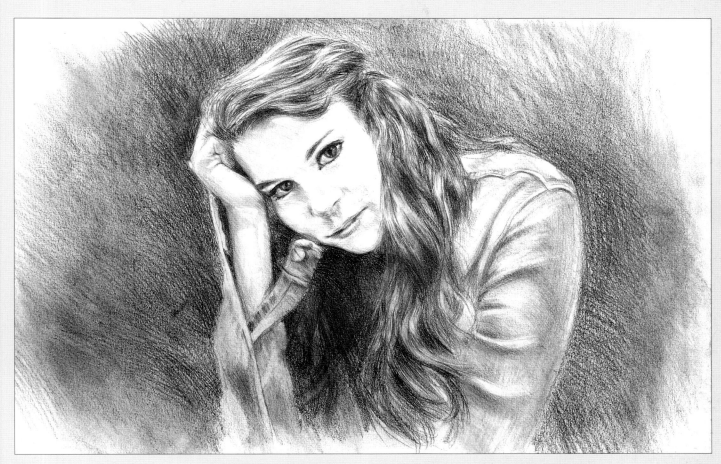

The dark shading here is only as dark as it needs to be to underpin the shape of the face.

Artist 2 also makes her left eye more important and weights his marks accordingly. This eyeline area grabs the viewer's attention first, with all other features being subordinate to this. The darkest dark is reserved for the pupils of the eyes.

PORTRAIT OF A YOUNG WOMAN

(10.2 X 14.6 IN. / 26 X 37 CM, GRAPHITE ON SMOOTH DRAWING PAPER)

"The challenge was capturing a likeness through close observation and measurement. I enjoyed trying to portray mysterious appeal through the humor around the eyes and mouth, the strength and directness of gaze, the softness and delicacy of skin. I simplified the background and any contrasting elements."

John Glover

COMPARING THE WORKS

Both artists have achieved a remarkable likeness, but the drawing by Artist 2 gives a softer, gentler impression. He has largely ignored the heavy makeup around the eyes, whereas Artist 1 has exploited this together with other dark tonal areas. His division of the background into two semi-abstract shapes gives the portrait an air of mystery.

Woodland scene

Upon first glance, the life of a reference may appear to come from its colors. How do you treat the brilliant splashes of orange in this photograph using a monochromatic medium? From stroke styles to variations in value, artists David Arbus and Richard McDaniel demonstrate the variety of ways to effectively render the glow of a fall using charcoal.

Materials
Soft-grade charcoal pencil
Kneaded eraser
Fixative
Smooth drawing paper

Techniques
Perspective, pages 26–27
Hatching, pages 13 and 17
Curved hatching, page 17
Stippling, page 13
Scribbles and squiggles, page 13
Blending, page 17
Lifting out highlights, page 17

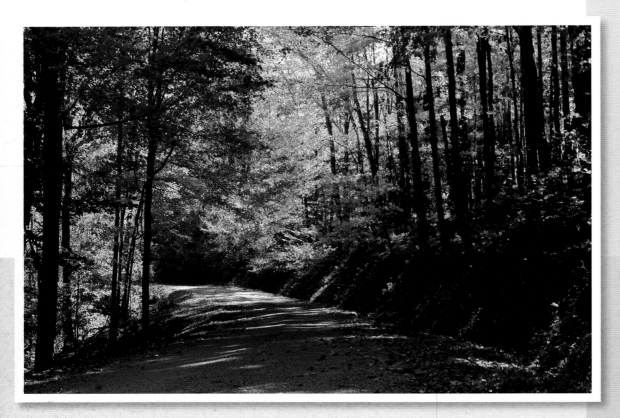

Materials
2B pencil
Medium-grade charcoal pencil
Scrap of cloth
Kneaded eraser
Blending stump
Smooth drawing paper

Techniques
Perspective, pages 26–27
Holding a pencil, page 12
Hatching, pages 13 and 17
Blending, page 17
Lifting out highlights, page 17

CHANGING THE FOCUS
This photograph's appeal heavily relies on the distribution of color, so the artists must concentrate on different aspects to create an interesting drawing. The delicate, lacelike leaves lend themselves to an intricate pattern of scribble, making texture a possible area of focus. Also, the sun filtering through the trees onto the pathway creates a dappled pattern of light and shadow, which the artists might choose to emphasize.

ARTIST 1:
David Arbus

Artist 1 prefers charcoal pencil over stick because it is capable of linear and tonal work and does not smudge as easily. He is interested in texture, varying sweeping strokes for the path and bank with short dabs and squiggles for the foliage. There is no blending in this high-contrast sketch.

SKETCH
The sweeping curve of the path provides the perspective indicator that will give the drawing its depth of field.

1 ESTABLISHING THE COMPOSITION
Artist 1 uses the soft-grade charcoal pencil to draw the shape of the path and the tree-trunk verticals. He then makes horizontal hatch marks to show shadow shapes, blending some of them with his finger.

ARTIST 2:
Richard McDaniel

Artist 2 combines graphite and charcoal pencil for a wide tonal range and soft feel. He is interested in the pattern of light and shadow and for the delicate edges of the foliage that catch the light, he uses a 2B pencil very lightly, holding it in the sketch grip. Blending creates a smooth, misty atmosphere.

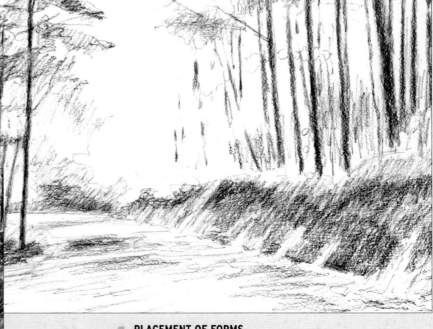

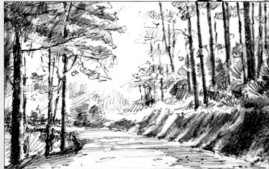

SKETCH
Artist 2's sketch uses predominantly mid- to high-key values, with the road bathed in light and soft shadow. This varies from the heavy darks of the reference image.

1 PLACEMENT OF FORMS
Using first a 2B pencil and then a charcoal pencil, Artist 2 uses the sketch grip to place the main elements on the drawing surface. His objective is the accurate placement of forms.

Still life

Traditional tabletop scenes have long been favorite subjects for artists. When skillfully arranged under dynamic lighting, they provide a range of textures, shapes, and tonal contrasts and often also include clear foregrounds and backgrounds that allow artists such as David Poxon and Myrtle Pizzey to play with a sense of depth using graphite.

■ **Materials**
HB pencil
B pencil
2B pencil
4B pencil
Blending stump
Plastic eraser
Flat paintbrush
Smooth drawing paper

■ **Techniques**
Composition, pages 28–29
Perspective, pages 26–27
Crosshatching, pages 13 and 17
Blending, page 17
Curved hatching, pages 13 and 17
Holding a pencil, page 12
Lifting out highlights, page 17

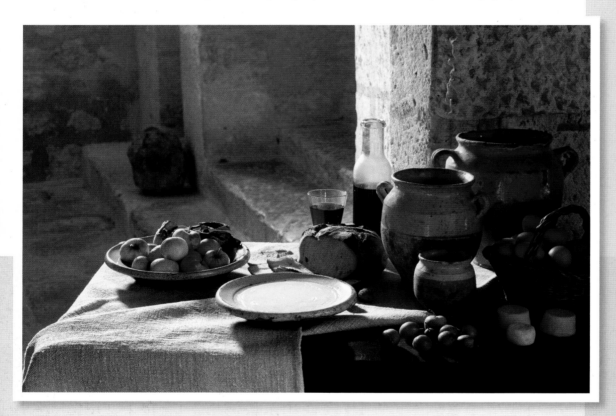

■ **Materials**
B pencil
2B pencil
3B pencil
6B pencil
Kneaded eraser
Smooth drawing paper

■ **Techniques**
Composition, pages 28–29
Hatching, pages 13 and 17
Crosshatching, pages 13 and 17
Curved hatching, pages 13 and 17

CHOOSING AN EMPHASIS
Because still lifes are "man made" and the elements already have been arranged to create an effective composition, artists can focus on the treatment of other aspects of the drawing. In this reference, the stark lighting creates interesting contrasts that could yield dramatic, moody results. Also the verticals and straight lines of the table complement the elliptical shapes of the pottery, providing the opportunity to emphasize pattern. And because the background is visible but subdued by shadow, the artists have the option of either pushing it back for a greater sense of depth or bringing it forward to involve it in the flow of the piece.

ARTIST 1:
David Poxon

Artist 1 works out his composition (in both linear and tonal terms) in advance, and then he builds up graphite in a series of layers, blending and lifting out at different stages. He identifies the light source, bathes the scene in subdued lighting, and achieves a sense of depth by keeping the background nondescript.

SKETCH
Artist 1 lays down grid lines and rectangular shapes to define the angles and curves of the objects. Tonal shifts are not his primary preoccupation at this stage.

1 LINE DRAWING
An HB pencil is used to lightly draw an accurate outline of the subject. Artist 1 drafts rectangles in one-point perspective at the points where the various ellipses of the jugs, bowls, and plates will be. He then can place the gently curving shapes more accurately within the rectangles. Usually just a faint outline of the main elements is good enough as a guide for subsequent stages.

ARTIST 2:
Myrtle Pizzey

For Artist 2, the initial line drawing made before adding tone is of supreme importance. She ensures that the relationship between objects is correct by drawing a grid of evenly spaced vertical and horizontal lines on the paper and measuring the distance between objects. This accurate drawing allows her to draw boldly and freely thereafter. Her focus is on pattern rather than form and depth.

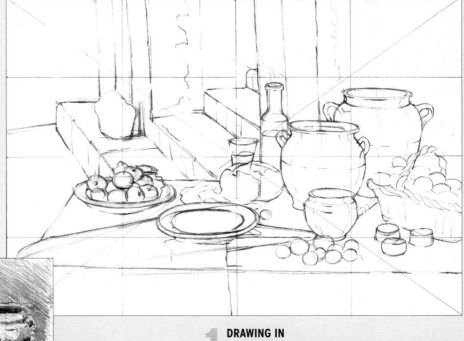

SKETCH
Artist 2 makes several initial sketches to explore shapes and tonal pattern.

1 DRAWING IN
Having worked out the grid structure, Artist 2 plots the positions of the objects. She draws in their outlines, taking care with the various ellipses. Horizontal and vertical grid lines help when tackling tricky drafting of curved and rounded subjects.

2 GRAPHITE WASH

Using both B and 2B pencils and crosshatching, Artist 1 applies the first layers of graphite. After each application, he blends with the stump, following the directions of the forms with an even-pressured, curving motion. He repeats this graphite "wash" stage several times, but leaves the extreme highlights of the tablecloth and foreground plate as white paper.

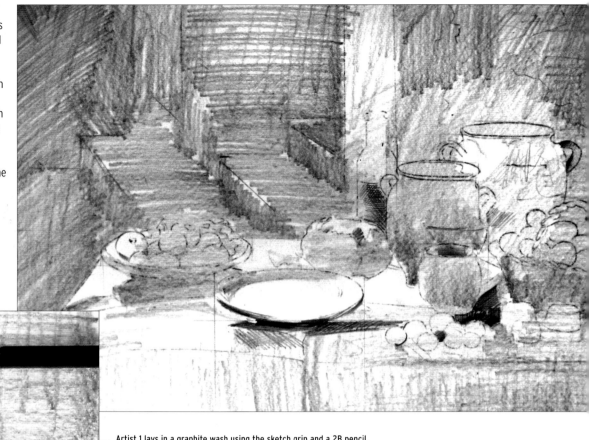

Artist 1 lays in a graphite wash using the sketch grip and a 2B pencil.

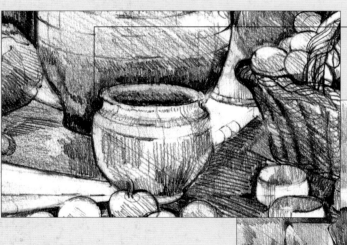

Artist 2 adds a dark value with the 2B pencil to define the gap between the small and large jugs.

2 APPLYING THE MIDTONES

Using B, 2B, and 3B pencils, Artist 2 starts to apply midtones to the entire drawing. She leaves highlights as white paper and does not add the darks at this stage. Where relevant, she uses directional lines to describe the shapes or angles of objects.

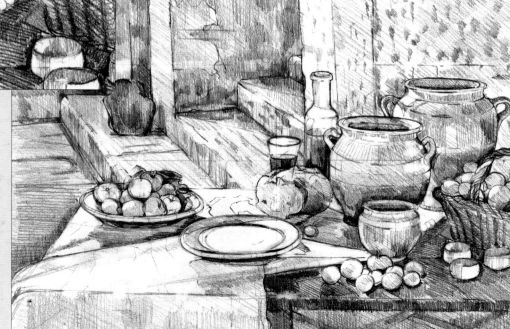

3 **ACHIEVING FULL VALUE**
Artist 1 uses B, 2B, and 4B pencils to bring the bowl of fruit to near completion, lifting out highlights where necessary with the plastic eraser. The full tonal range within the fruit bowl serves as a benchmark, enabling him to judge the other applications of tone and relative light and dark values throughout the drawing.

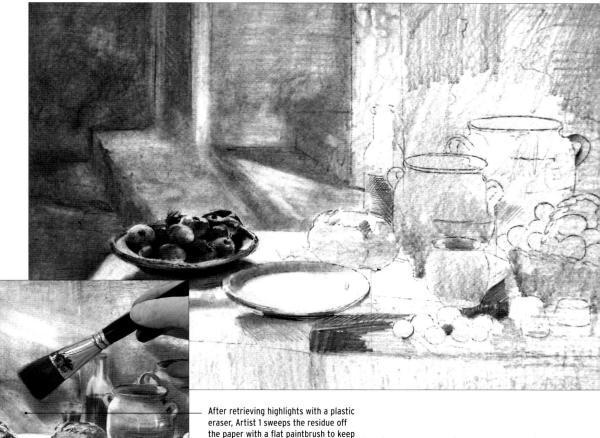

After retrieving highlights with a plastic eraser, Artist 1 sweeps the residue off the paper with a flat paintbrush to keep the working surface clean.

3 **ADDING TEXTURE**
Soft shading with two or three midtone values suggests the uneven surface of ancient plaster walls. Artist 2 introduces deeper tones, especially to the lower right-hand corner, and uses negative shapes to pick out the forms of the lightest objects in the composition.

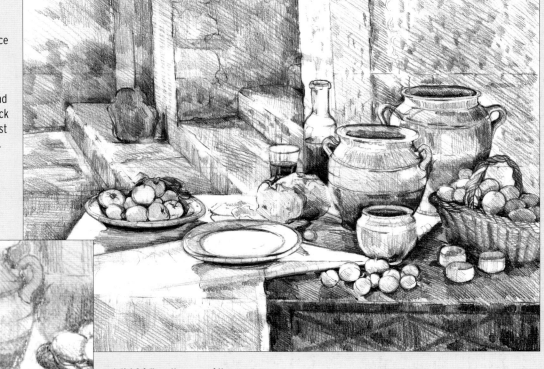

Artist 2 follows the curve of the jug with a 2B pencil.

FINAL STAGE

Artist 1 reaches full tonal value by applying more 4B pencil and then works on all the other table objects. He blends in the extreme highlights on the pottery to suggest their reflective, glazed surfaces. He draws the tablecloth delicately to give the feel of cotton. Finally, he brings the subject to life by introducing a raking diagonal light from top left to right.

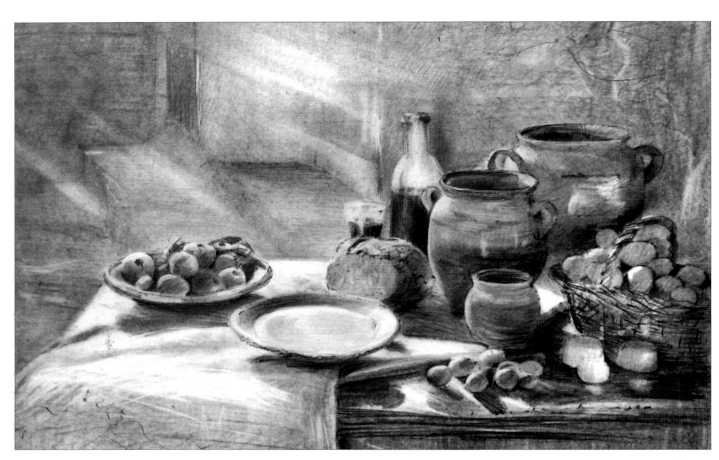

Artist 1 uses the left-hand light source to good effect. The lit edges and translucency of the bottle create a pleasing mix of heightened definition and dimension.

Artist 1 uses tonal blending to convey a subdued atmosphere. By working predominantly in lower midtonal value and preserving extreme highlights for important edges, the background shapes are kept simple and understated.

EXPECTING COMPANY
(11 X 16 IN. / 28 X 41 CM, GRAPHITE ON SMOOTH DRAWING PAPER)

"With this type of multiple-object subject, it's easy to lose oneself in the individual detail instead of focusing on the scene as a whole. Having rehearsed various technical issues, particularly the ellipses, I am able to tackle the whole drawing more confidently. To unify the composition, I use the light source to weave the objects together, creating an ambient and subtle interior space."

David Poxon

FINAL STAGE

Artist 2 increases the depth by adding further layers of graphite. She establishes the shadow areas with the 6B pencil to reinforce the lightest areas. She treats the darkest darks of the shadows in the same way, taking particular care to ensure that all of the lightest surfaces are on the left side of the objects.

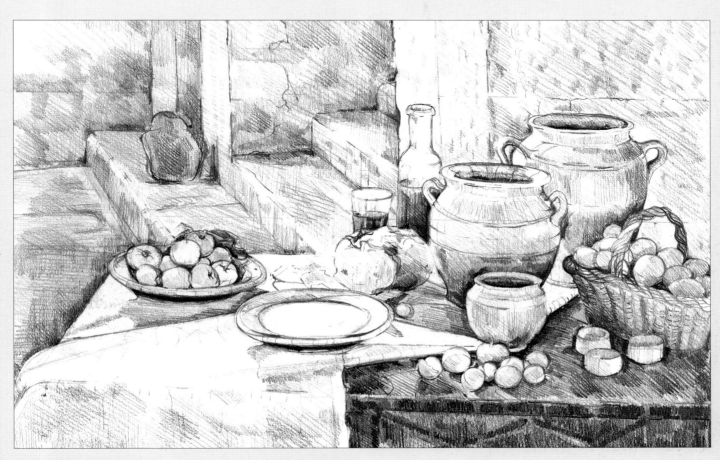

Artist 2 creates a loose distribution of light and shadow, mainly in the mid- to high-key value range with a minimal use of darks. This results in a composition that looks slightly flat, and outlining objects is necessary to indicate their edges.

Angled and curved hatching and crosshatching strokes are applied throughout the drawing to describe form. The hatching strokes on the tabletop show the perspective direction and help steer the viewer into the composition.

A FRUGAL LUNCH

(10.6 X 14.1 IN. / 27 X 36 CM, GRAPHITE ON SMOOTH DRAWING PAPER)

"These natural and man-made objects rest on a table in the cool of the kitchen. Sunlight streams in, providing a strong light source from the left. An initial sketch helps to establish the spatial relationships between objects and setting. Applying tone adds depth and drama."
Myrtle Pizzey

COMPARING THE WORKS

The composition is similar in both drawings, but the effects could not be more different. Artist 1's study is beautifully somber, with strong tonal modeling and the objects woven together in a series of interlocking light and dark shapes. Artist 2's interpretation is lighter and more airy. She has treated the right-hand group of objects as light shapes on dark to echo those in the bowl and basket.

Hilltop village

A cascading hilltop village is a quaint but sometimes intimidating subject for an artist, as it is full of small shapes, distinct angles, and strong shadows. However, scenes like this provide the artist with an opportunity to impose order and create an appealing visual rhythm. Both Martin Taylor and Ron Law use charcoal to establish shapes and high contrasts quickly.

■ **Materials**
Charcoal pencils (hard, medium, and soft)
Plastic eraser
Drawing paper

■ **Techniques**
Composition, pages 28–29
Hatching, pages 13 and 17
Blending, page 17
Stippling, page 13

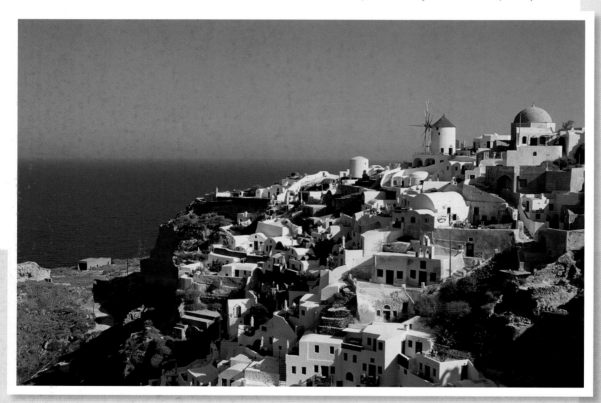

GUIDING THE EYE TO A FOCAL POINT
The busy nature of this reference makes it crucial to guide the viewer's eye to the focal point of the composition (the windmill). One technique involves directional hatching, which "points" the eye in the appropriate direction through the flow of the strokes. The artist also can employ tonal techniques to highlight the focal point—juxtaposing the dark tones with the white of the paper creates strong, eye-catching contrasts. Artists also can choose to emphasize existing compositional elements that lead the eye to the windmill, such as the horizon line or the diagonal band of white buildings.

■ **Materials**
Medium-grade charcoal pencil
Kneaded eraser
Plastic eraser
Sable brush
Drawing paper

■ **Techniques**
Composition, pages 28–29
Blending, page 17
Lifting out highlights, page 17

ARTIST 1:
Martin Taylor

Artist 1 spends time working out the composition before committing himself to the actual drawing. He then creates an accurate line drawing, establishing the main shapes, and does not begin to build up tonal value until he is satisfied with this drawing. He uses three different grades of charcoal pencil, from hard to soft. To downplay the background and ensure a focus on the busy buildings, Artist 1 uses directional hatching in shadows to lead the eye up the hill.

SKETCH
Artist 1 makes several small studies, limiting himself to four values, to arrange the value pattern of his composition.

1 OUTLINE DRAWING
Using the hard charcoal, Artist 1 outlines the main shape of the village and draws the horizon line high in the picture plane, at the point where it first touches the buildings. He decides to make the windmill his main feature and increases its size slightly. The dramatic appeal of the subject is maintained by emphasizing the steep diagonal fall from top right to bottom left.

ARTIST 2:
Ron Law

Artist 2 approaches the scene in a different way, focusing on the central cluster of buildings and deciding which ones to leave out. His first priority is to make visual sense of the complex scene. He emphasizes the horizon and the tone of the ocean. His combination of bold lines and blended tone provides a nice contrast that helps to suggest the intricacies of the scene. He uses a medium-grade charcoal pencil for the drawing.

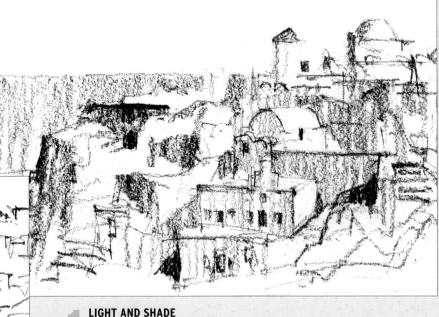

SKETCH
In his working sketch, Artist 2 decides to focus on the windmill, merely suggesting the mass of buildings cluttering the hillside.

1 LIGHT AND SHADE
Artist 2 does not begin with an outline drawing, as he wants to establish the tonal pattern from the outset. He gives extra prominence to the foreground buildings and the curved roof in the center of the picture, as these will be used to help lead the eye to the focal point.

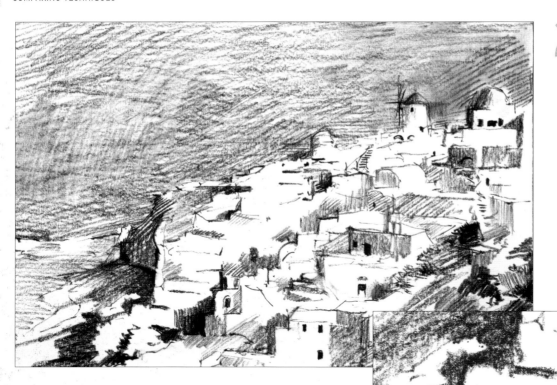

2 FIRST TONAL BLOCKING
With the soft charcoal pencil, Artist 1 starts to block in the sky and shadows on the buildings with a light midtone. He keeps his application loose and then switches to the hard pencil, applying clean, hatching strokes to consolidate the shadows.

Artist 1 uses a hard pencil, which is still much softer than graphite and can produce rich darks.

2 BLOCKING IN
Artist 2 concentrates on tonal value now. Each pass of the rich darks further emphasizes the whites. He lightens areas of sky with a kneaded eraser, but darkens it on the right to emphasize the windmill.

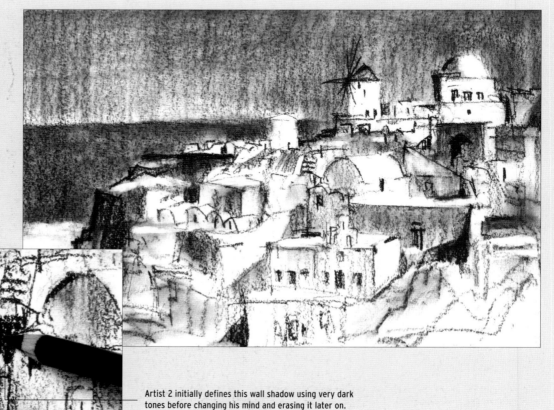

Artist 2 initially defines this wall shadow using very dark tones before changing his mind and erasing it later on.

3 **BLENDING TONES**
With the soft pencil, Artist 1 adds more tonal definition. He uses finger blending for the sky behind the windmill and then the ocean, gradually increasing the depth of tone as it touches the landmass on the right. Some of the building shapes are sharpened with firm, black lines. To suggest depth, some of the more distant sky edges and the horizon are softened with a plastic eraser.

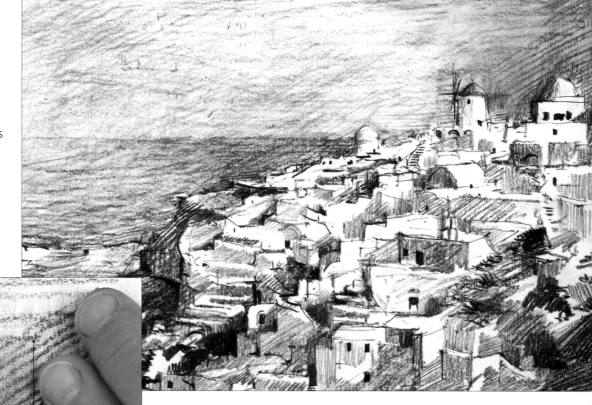

Finger blending is more accurate and controllable than rag blending.

3 **TIGHTENING UP**
Working on the buildings, Artist 2 adds windows and doors and sorts out some of the edges. As the village recedes up the hillside, details become less defined to suggest distance. Note which buildings he chooses to tighten and which he keeps as loose, sketchy impressions.

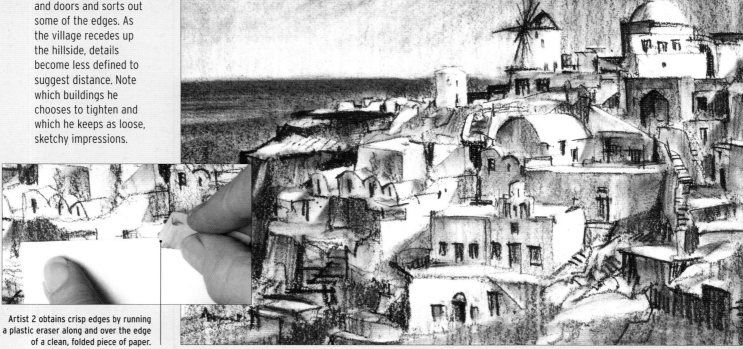

Artist 2 obtains crisp edges by running a plastic eraser along and over the edge of a clean, folded piece of paper.

Interior

Room interiors are a popular subject with artists, especially when combined with a view to the outside world. In this photograph, the viewpoint (from the inside looking out) places the viewer directly in the scene, making it seem as if he or she is in the moment. David Arbus and David Poxon choose graphite and different compositional approaches.

Materials
HB pencil
2B pencil
4B pencil
Plastic eraser
Fixative
Drawing paper

Techniques
Perspective, pages 26–27
Composition, pages 28–29
Hatching, pages 13 and 17
Curved hatching, page 17
Blending, page 17
Lifting out highlights, page 17

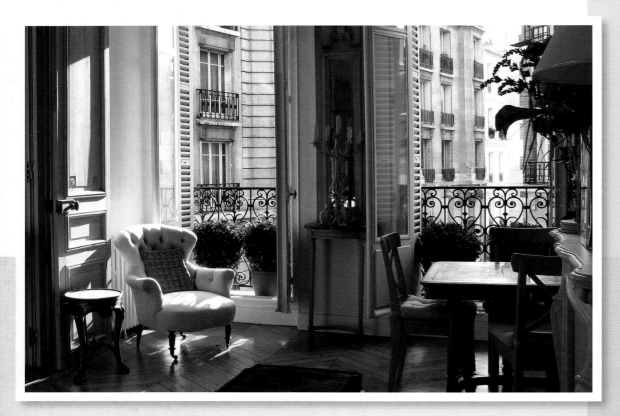

COMPOSING A SCENE
The way in which an artist decides to crop a scene will help determine the focal point. In this reference, the sunlit chair in the bottom left quadrant of the composition is the focal point—the eye is drawn there by the contrast of light and shadow and the low placement of the chair. "Zooming in" on the scene will emphasize the focal point, whereas "zooming out" of the scene will give equal importance to all the elements so the scene is taken as a whole.

Materials
B pencil
2B pencil
4B pencil
Blending stump
Angle finder
Button
Ruler
Kneaded eraser
Drawing paper

Techniques
Perspective, pages 26–27
Composition, pages 28–29
Finding angles, page 26
Hatching, pages 13 and 17
Crosshatching, pages 13 and 17
Blending, page 17
Lifting out highlights, page 17

ARTIST 1:
David Arbus

Artist 1 uses a unique method to create this drawing: After transferring a detailed line drawing of the scene to his art paper, he builds up one area at a time, rather than gradually developing the tones over the entire picture. This helps him achieve a pleasing tonal range in one small area, which he can then use as a gauge for developing the rest of the drawing. He zooms out slightly, showing more of the foreground and giving equal importance to the elements in the room to guide the eye.

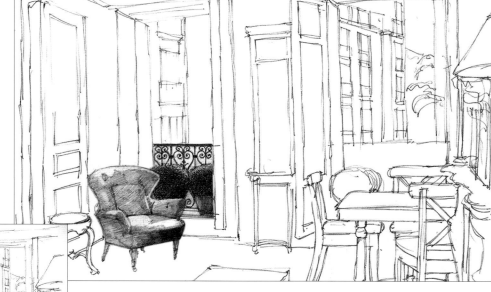

1 ESTABLISHING KEY TONES
Artist 1 selects an area of the room that he feels offers the most complete tonal range from dark (the potted plants) to light (the highlights on the back and seat of the chair) plus some nice detail (the iron balcony railing). He works specifically on this area with a 2B pencil.

SKETCH
Artist 1 makes a detailed line drawing of the room and furniture. To check for accuracy, he frequently turns his work upside down.

ARTIST 2:
David Poxon

Artist 2 completes the drawing in a more traditional manner by building up the tones gradually all over the picture. He zooms in, drawing the chair lower in the composition than it is in the photograph to create a sense of intimacy. He also creates a high-contrast area on the chair at the left and points toward it with diagonals of light.

1 LINE DRAWING
Concerned with accuracy, Artist 2 uses a ruler to construct the main perspective lines. He uses an angle finder to check the various angles and pays special attention to proportions.

SKETCH
Artist 2 places the furniture on a perspective grid. This method offers the best means of recording the various changes in planes. Some initial tonal exploration suggests form.

FINAL STAGE
Artist 1 fixes the graphite with fixative to protect it from
smudging. Then he completes the image with additional tones
and touches of detail that bring out the pattern element.

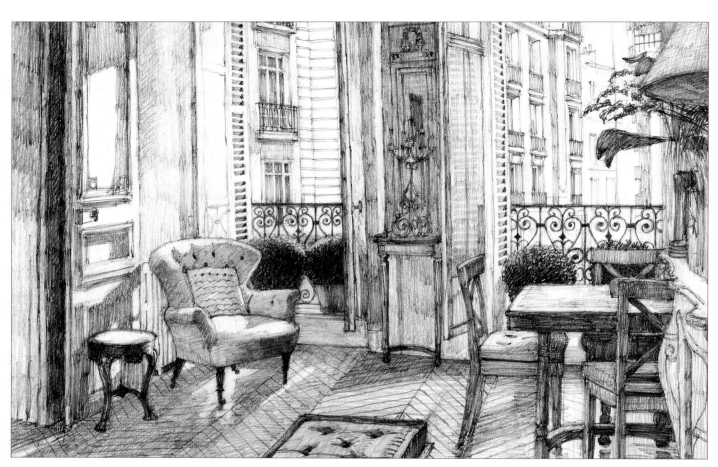

Artist 1 shows the
small table fully,
complete with legs
and feet, relying on
the angled lines of the
parquet floor to indicate
perspective direction.

CITY INTERIOR
(18 X 24 IN. / 45.7 X 61 CM, GRAPHITE ON DRAWING PAPER)

"A monochrome composition can often be more atmospheric
than a color picture. The complex arrangement of shapes,
light, and shade provides the artist with the opportunity for
exercising his or her draftsmanship which is pleasurable
in itself."

David Arbus

The glass window is an
important feature of the
room. Artist 1 suggests
its transparency by
reflecting the faint lines
of the buildings beyond.

FINAL STAGE

Artist 2 applies rich darks with a 4B pencil. He completes the potted plants and emphasizes important areas bathed in sunlight by lifting them out with a kneaded eraser. As a final, enlivening touch, he uses the eraser to illuminate the chair with diagonal shafts of light.

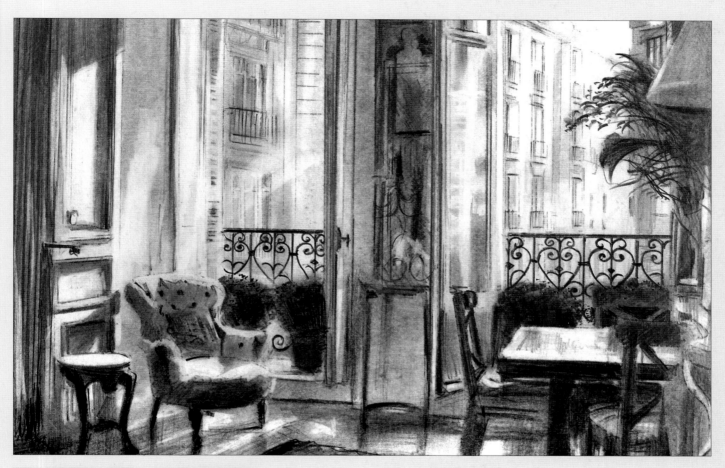

Artist 2 makes the table legs disappear off the picture plane. This has the effect of engaging the viewer with the subject immediately.

Artist 2 uses the window as an opportunity to suggest the bright, reflective light outside. This and other reflected light surfaces enhance the sense of atmosphere in the drawing.

YOUR CHAIR
(11 X 16 IN. / 28 X 40.6 CM, GRAPHITE ON DRAWING PAPER)

"I tried to establish depth of field by relating the interior subject to the cityscape. The chair became my main center of interest. Perspective search lines reach out to the distant window lines. Soft focus, lost edges, and elegant furnishings create an inviting room."
David Poxon

COMPARING THE WORKS

The compositions of the two drawings are similar but not identical. Artist 1 has adhered to the reference photograph because he wanted to use the table and the lines of the parquet floor to lead the eye into the scene, whereas Artist 2 has cropped the image at the bottom to give more space to the windows, making the chair a stronger focal point.

Floral landscape

This vibrant floral landscape provides an exciting opportunity to introduce color into a drawing. The artists, Myrtle Pizzey and Richard McDaniel, must each determine how to simplify the composition to make it more approachable, where to establish the center of interest, and what color scheme to use. The possibilities are endless.

■ **Materials**
Colored pencils
Drawing paper

■ **Techniques**
Hatching, pages 13 and 17
Holding a pencil, page 12
Blending, page 17

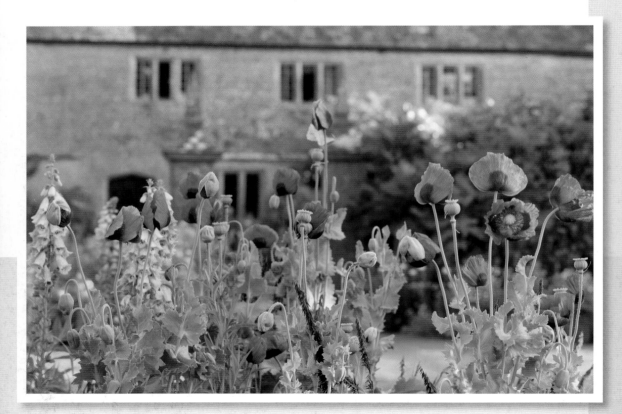

MODIFYING A REFERENCE
This composition is somewhat cluttered, especially on the left side where the poppies overlap the lupins. Moreover, the gap between the two groups of flowers is distracting. To make this scene more manageable, the artists may choose to omit, rearrange, or simplify some of the elements. When rearranging the elements, each artist must create a visual path to direct the eye to the focal point—and then emphasize that focal point through differences in size, color, shape, or detail. Finally, to establish color harmony, the artists may decide to place warms against cools, contrast lights against darks, use an analogous scheme, or juxtapose complements.

■ **Materials**
2B pencil
Colored pencils
Drawing paper

■ **Techniques**
Holding a pencil, page 12
Hatching, pages 13 and 17
Crosshatching, pages 13 and 17

ARTIST 1:
Myrtle Pizzey

Artist 1 uses a full range of value and colored pencils to create expressive linework and interesting tonal patterns. She renders the lupins in a line behind the poppies and creates a yellow pathway to help lead the eye into the scene.

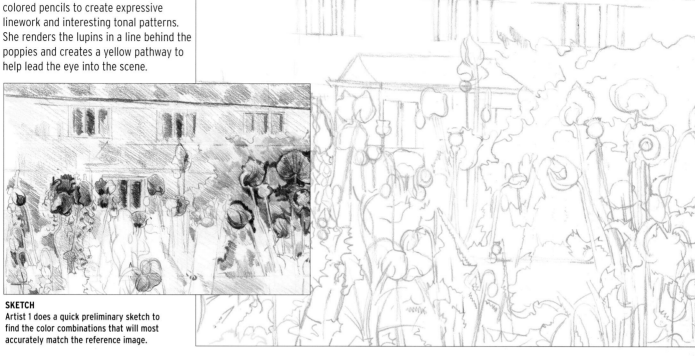

SKETCH
Artist 1 does a quick preliminary sketch to find the color combinations that will most accurately match the reference image.

1 LINE DRAWING
Artist 1's main outlines are in green. Find a color for your initial sketch that will blend in with subsequent applications of color.

ARTIST 2:
Richard McDaniel

Artist 2 uses colored pencils more as a painting medium, applying one color layer over another for a soft, blended effect. To simplify the scene, he omits the building in the background and reduces the number of flowers to concentrate on the light reds of the poppies, which are complements of the green stems and leaves.

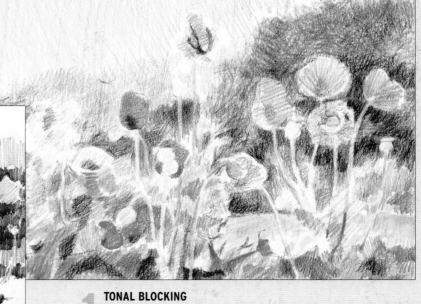

SKETCH
Artist 2's sketch establishes the main tonal patterns of the subject.

1 TONAL BLOCKING
Artist 2 decides to rearrange the composition by moving the central blossom to the right. Using the sketch grip, he applies the first key colors and concentrates on blocking in the main flower shapes.

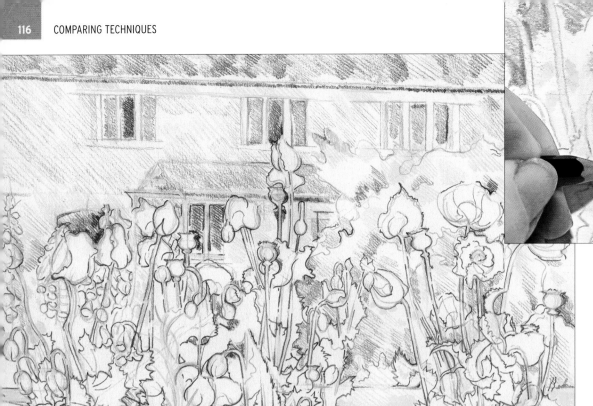

Artist 1 adds diagonal lines of hatching to build up the dark areas around the flowers and stems.

2 FIRST COLORS

Using a selection of cool blues and yellows, Artist 1 begins blocking in the background areas. She keeps the hatching strokes soft and mostly diagonal.

2 ECHOING COLORS

Artist 2 decided at the outset that the building was not necessary, but he needed a band of red across the top to echo the color of the flowers. Now he hatches in a light green to pick up the colors of the foliage and crosshatches dark tone around the flowers, pushing them into the foreground.

Artist 2 uses a hatching technique to blend colors visually, layering one pigment over another.

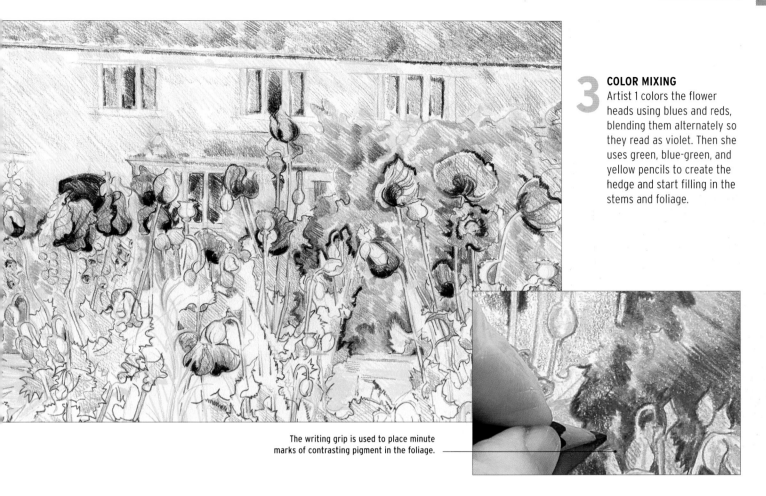

3 COLOR MIXING
Artist 1 colors the flower heads using blues and reds, blending them alternately so they read as violet. Then she uses green, blue-green, and yellow pencils to create the hedge and start filling in the stems and foliage.

The writing grip is used to place minute marks of contrasting pigment in the foliage.

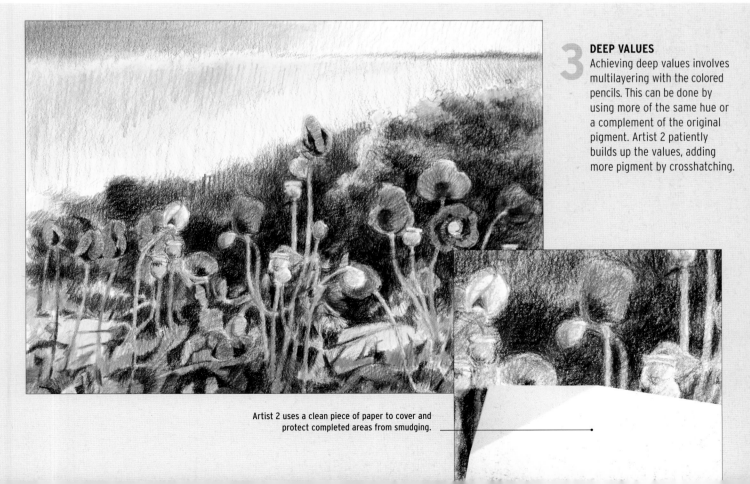

3 DEEP VALUES
Achieving deep values involves multilayering with the colored pencils. This can be done by using more of the same hue or a complement of the original pigment. Artist 2 patiently builds up the values, adding more pigment by crosshatching.

Artist 2 uses a clean piece of paper to cover and protect completed areas from smudging.

FINAL STAGE
Once most of the flowers are in position, Artist 1 finishes the building in the background, and then emphasizes the color of the flowers on the right by surrounding them with the complementary greens and yellows of the foliage. She overlays transparent color where needed.

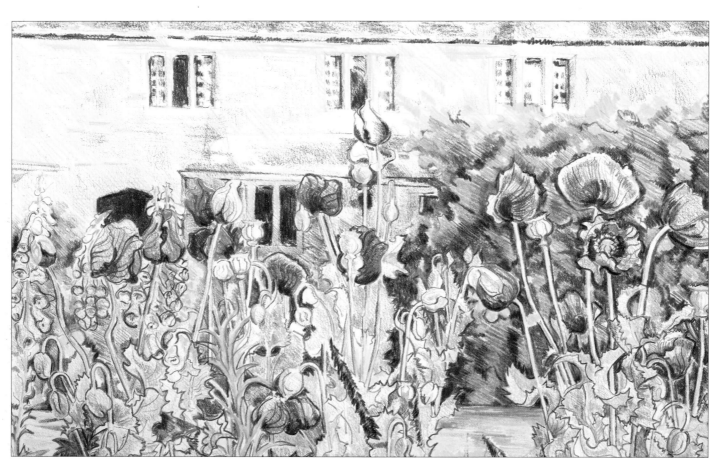

The dark window has the effect of pushing the flower shapes forward, toward the viewer. This becomes a focal point in the drawing.

The flower stems and leaves are intricately woven and left as midtone colors against the darker background.

PAPAVERS IN THE EVENING LIGHT
(9 X 12 IN. / 23 X 30.5 CM, COLORED PENCIL ON DRAWING PAPER)

"Low evening light in late spring causes the papaver flowers to become silhouetted against the backdrop of a building. Their transparent magenta-purple petals allow the light to shine through, causing an iridescence. Color is slowly built up with colored pencils, gradually creating tonal depth, to give the piece the waxy feel created by the cool evening light."
Myrtle Pizzey

FINAL STAGE

Artist 2 adds more layers of pigment to surround the brilliant flowers with dark tones. He strengthens the contrast in some areas, particularly the tall flower, which is the main focal point, and fades out the left-hand background to suggest depth.

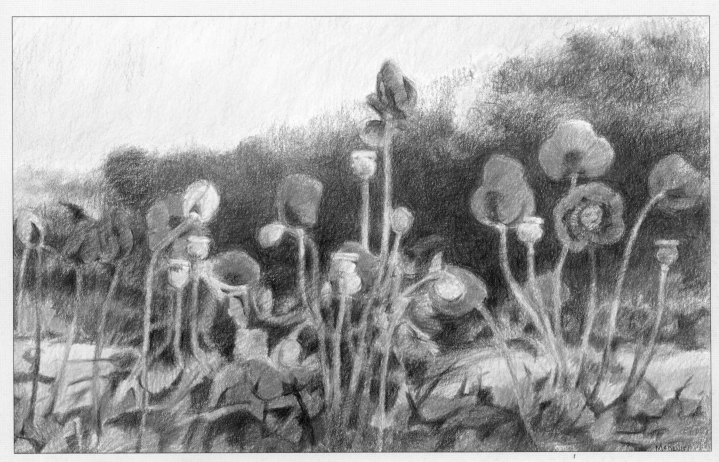

A rich band of purple and blue stretches across Artist 2's work. Against this, all of the flower shapes are set in lighter, brighter hues.

The stem and leaf areas are simplified by Artist 2. He relies on a pattern of complementary colors (green against pink) instead to draw the viewer's attention.

BLOSSOM PARADE

(9 X 11.8 IN. / 23 X 30 CM, COLORED PENCIL ON DRAWING PAPER)

"When I first saw the photograph, I liked the flowers but didn't care for the background as there wasn't enough to suggest a story. I decided to downplay the shape of the building and concentrate on the real subject, which is the flowers."

Richard McDaniel

COMPARING THE WORKS

The compositions and treatment in the two drawings are very different, but what both have in common is the use of complementary colors. Artist 1 made some of the flowers more violet to contrast with the yellows in the foreground and background, whereas Artist 2 used pure reds for the flowers to set up the red-green contrast.

Floral still life

Although this colorful still life is a traditional subject, the elements are not arranged in a formal manner. Instead, the flowers, reflective vase, and shiny apples compete for attention. These opposing features pose a challenge to Peter Woof and Robert Maddison, who must decide which objects to emphasize and which to play down in their colored pencil drawings.

■ **Materials**
B pencil
Colored pencils
Kneaded eraser
Cold-pressed drawing paper

■ **Techniques**
Composition, pages 28–29
Crosshatching, pages 13 and 17
Blending, page 17
Stippling, page 13

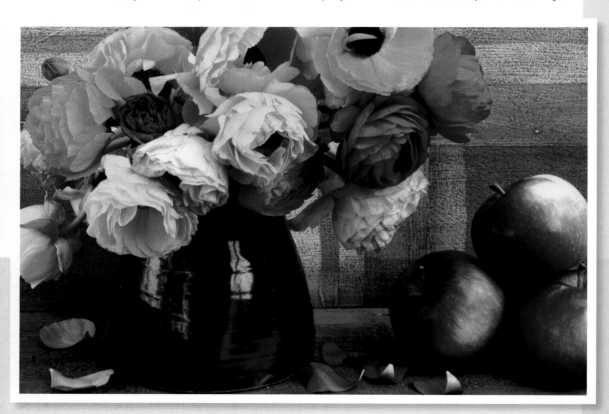

ORGANIZING THE COMPOSITION
The green vase might appear to be the obvious focal point (partly because of its solidity and partly because the bright highlight is positioned next to an intersecting third, demanding attention), but it doesn't have to be. The artists may choose to minimize the importance of the vase and instead focus on the vibrant blossoms or even the smooth apples. No choice is right or wrong—creating original work that expresses your own style and personality is just one of the many joys of being an artist!

■ **Materials**
2H pencil
Colored pencils
Watercolor pencils
Kneaded eraser
Fixative
Drawing paper

■ **Techniques**
Composition, pages 28–29
Blending, page 17
Lifting out highlights, page 17

ARTIST 1:
Peter Woof

Artist 1 uses soft colored pencils in a painterly fashion, building up depth of color and tone both by layering and by applying fully saturated color. He gives more or less equal weight to the reds throughout the composition, setting up a strong complementary contrast with the greens of the vase and in the background.

1 INITIAL LINE DRAWING
Artist 1 uses a B pencil to make a detailed line drawing. He draws the highlights accurately, as these will be reserved for pale color.

SKETCH
Artist 1 uses the sketch to explore the subject, looking for ways to handle the composition and deciding where to focus the main tonal shifts.

ARTIST 2:
Robert Maddison

Artist 2 also uses strong, vibrant colors, working from light to dark, but he chooses to use both soft and water-soluble colored pencils (these can be washed over with water to produce complex and layered watercolor effects). He decides to play down the apples and treat the flowers with more detail, making the vase and flowers the focal point.

1 OUTLINE DRAWING
Using a 2H pencil, Artist 2 also makes an outline drawing as the first stage, keeping the lines light.

SKETCH
Artist 2's preliminary pencil drawing is a detailed exploration of the intricate interlocking petal shapes.

FINAL STAGE

Artist 1 now applies all the reds and oranges. To keep the colors fresh, he avoids using black for the shadow areas. Further layering and final additions of color complete his picture.

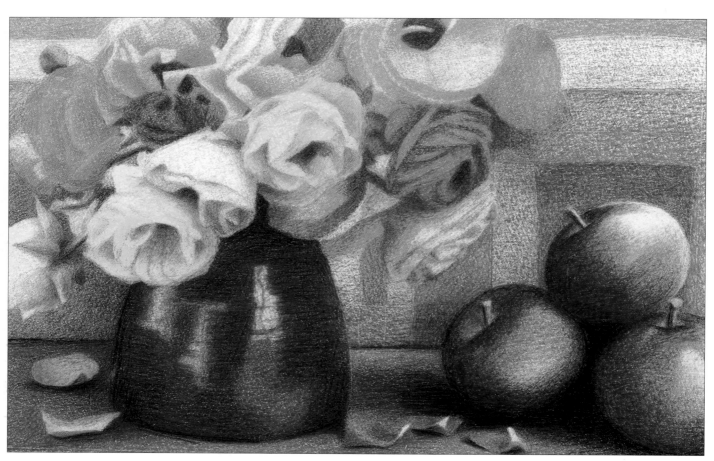

Artist 1 renders the jug in a similar technique to the flowers. There is little differentiation between the types of strokes used.

Subtle tonal changes define the forms of the flowers and separate one from another.

SUMMER ROSES

(5.3 X 7.9 IN. / 13.5 X 20 CM, COLORED PENCIL ON COLD-PRESSED DRAWING PAPER)

"The vibrant hues of the flowers make this an ideal subject for colored pencil drawing. The challenge of this composition lay in accurately describing the various textures of the elements involved. I used light to convey the shape and feel of the vase while building colors up slowly, layer by layer. This helped to capture the soft texture of the petals. Keeping the colors strong was key."

Peter Woof

FINAL STAGE

Artist 2 works over the entire image, strengthening the tones and colors with both dry and water-soluble pencils. He adds in the apples and foreground details and finally polishes the surface of the completed picture with a soft cloth. He then sprays it with fixative.

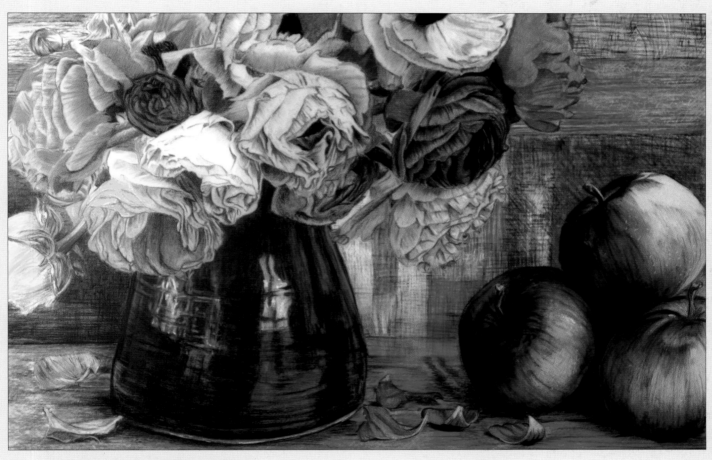

Artist 2 draws the jug reflections in great detail. The pale blue highlight gives us a hint of the light source, perhaps a window across the room.

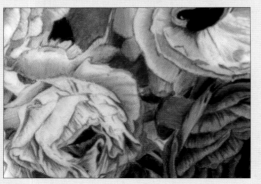

A full range of tones is used by Artist 2 in the flower areas. Each petal receives similar attentive detail work.

ROSES AND APPLES

(10.2 X 15 IN. / 26 X 38 CM, COLORED PENCIL ON DRAWING PAPER)

"The essential qualities of my drawing are the intensity of color, the complexity of pattern and shape, and the way the organic flower shapes interact with the geometric shapes of the background. I really enjoyed my formal investigation into its abstract qualities."

Robert Maddison

COMPARING THE WORKS

The composition is virtually the same in both drawings, but the treatments reveal the artists' different interests. Artist 1 has treated the subject as an essay in color and has used only enough detail to give the flowers shape and form, whereas Artist 2 has been fascinated by the intricacy of the flowers, as well as the contrasts of texture.

Index

Credits

All photographs and illustrations are the copyright of Quarto Publishing plc.

While every effort has been made to credit contributors, Quarto would like to apologize should there have been any omissions or errors, and would be pleased to make the appropriate corrections for future editions of the book.

Quarto would like to thank J.S. Staedtler for sending us samples of their wide range of high-quality writing and coloring products.

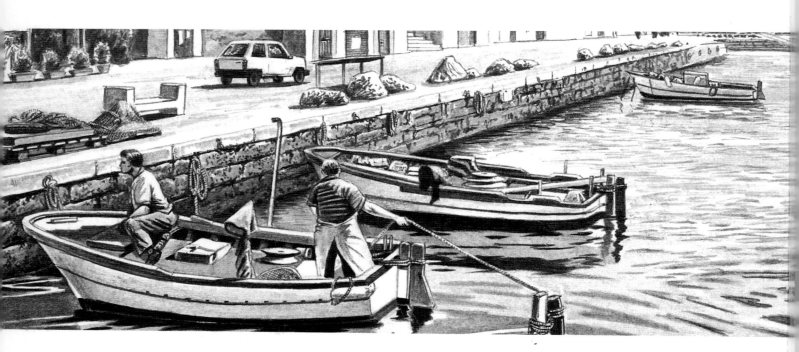